INSPIRED SHAPES

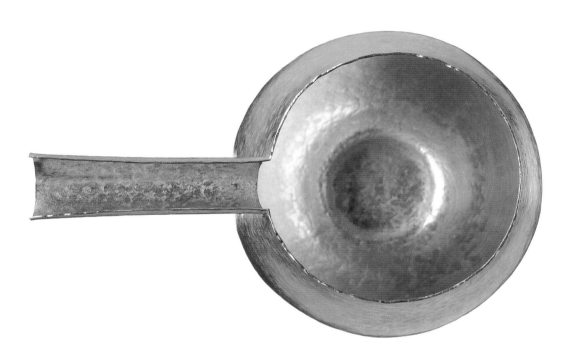

INSPIRED SHAPES

Contemporary Designs for Japan's Ancient Crafts

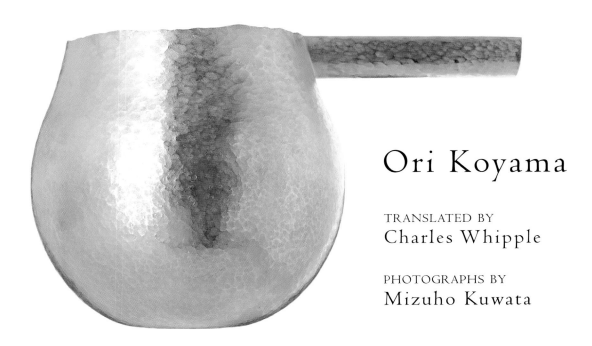

Ori Koyama

TRANSLATED BY
Charles Whipple

PHOTOGRAPHS BY
Mizuho Kuwata

KODANSHA INTERNATIONAL
Tokyo • New York • London

Distributed in the United States by Kodansha America Inc., and in the United Kingdom and continental Europe by Kodansha Europe Ltd.

Published by Kodansha International Ltd., 17–14 Otowa 1-chome, Bunkyo-ku, Tokyo 112–8652, and Kodansha America, Ind.

ISBN-13: 978–4–7700–2950–8
ISBN-10: 4–7700–2950–0

First edition, 2005
12 11 10 09 08 07 06 05 10 9 8 7 6 5 4 3 2 1

www.kodansha-intl.com

CONTENTS

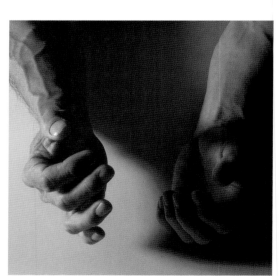

PREFACE

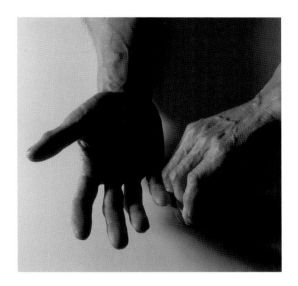

I was born and raised in Tokyo, the daughter of a third-generation sake brewer. The site of the family brewery was my childhood playground, and I remember watching, enthralled, as the men wielded tools that had not changed for centuries, brewing the sake with great oar-shaped stirring sticks, or repairing and renovating the antique vats. It was my first encounter with craftsmen, their tools and their trade, and looking back I wonder if my present fascination with those subjects began way back then.

I worked toward a degree in art history during my university days, though I'm ashamed to admit that my studies suffered from a more pressing interest in polishing my techniques on the ski slopes. But every year, when summer vacation time rolled around, I found myself in Nara at the student boarding house, packing *onigiri* rice balls for my lunch, then making my way around the historical treasures of that ancient city and neighboring Kyoto, viewing with particular awe the beautiful stone Buddhist sculptures carved by devout artisans long ago.

My days of freedom ended as graduation approached, and my curiosity about Japanese traditional arts was placed on the back burner, the more immediate necessity being to find work. My skiing career had to be abandoned after a bone-breaking accident, which—fatefully for me—had the effect of narrowing my work prospects down to a publisher who, several years later, would launch a magazine on Western interiors and interior styling targeted at young women. Soon I found myself deeply engrossed in the subject, and I had neither the time nor inclination to reflect upon the historical arts of Japan that I had been so interested in as a student. Any free time I had was spent poring over books on interior styles from all over the world, and Western magazines like *Elle, Casa Vogue* and *World of Interior* until they were dog-eared.

Some years later, I left the publisher and set up my own atelier as an independent interior stylist. I was producing pages for a number of magazines, and planning interior exhibitions for galleries and other spaces when I was asked by the French interior coordinator Catherine Memmi to become the visual coordinator for her Tokyo shop.

It was her concentration on simple forms and superior quality that turned my head once again toward traditional Japanese arts and crafts, since I found they possess the same values. What a joy it was to once more realize the incredible beauty of handmade pieces of art from my own culture. And what a pleasure it was to meet the artists and to share their secrets. I found myself transported back to childhood, reveling in the warmth of creative craftspeople, watching their hands produce their works in almost magical ways.

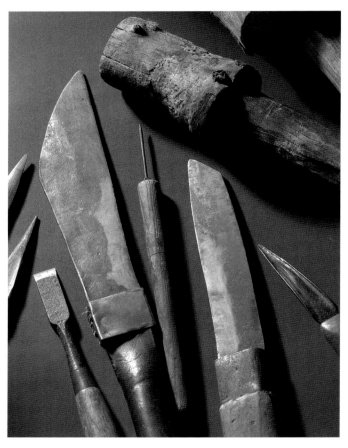

My favorite artists are those whose works have a universal appeal—grounded in traditional techniques yet informed by modern aesthetics, and made to be used and appreciated. Finding such artists, and introducing them and their art to the general public became my goal.

About ten years ago, for example, I happened to see an exhibition of the work of Naotomo Inagaki, one of the bamboo artists featured in this book (and the man whose weathered hands and tools decorate this preface). It included chairs of bamboo that still had their roots, beds, lamp frames, chopsticks, and forks of *susutake* bamboo, ceiling pieces blackened over centuries by the smoke of cooking fires. Among the pieces, my eyes fell on a high-backed chair of susutake. I was mesmerized. My feet absolutely refused to carry me further.

Bamboo is representative of traditional crafts in Japan, and no type of bamboo is more a product of Japanese culture and lifestyles than the black and gold susutake. Yet the chair exuded a universal aura reminiscent of Asia, even Western

Europe. It was impressively old, yet so amazingly new, and ever since that day, the chair sits in my own front room.

The items I've chosen for this book have all had a similar effect on me. They make me proud of our craft traditions. But they also put me in mind of the present, as their beauty is enhanced by actual use. And, finally, they speak of the future, because for anyone to work with traditions means they must hand down skills and ways of seeing—and to do this takes minds sufficiently nimble to look backward and forward at the same time.

Ori Koyama

NOTE: Japanese names are given in the Western order, given name first, family name second. The major eras of Japan's historical timeline are:

Jomon (10,000–300 B.C.)	Muromachi (1333–1568)
Yayoi (300 B.C.–300 A.D.)	Azuchimomoyama (1568–1600)
Kofun (300–645)	Edo (1600–1868)
Asuka (645–710)	Meiji (1868–1912)
Nara (710–794)	Taisho (1912–1926)
Heian (794–1185)	Showa (1926–1989)
Kamakura (1185–1333)	Heisei (1989–)

BAMBOO

The image of a gently swaying grove of green bamboo, planted as a windbreak to protect a rural rice farm, is an enduring cultural symbol to many Japanese, regardless of their upbringing in city or country. Indeed, it would be quite impossible to separate this ubiquitous grass from the collective psyche.

More than 600 species of bamboo grow in Japan—some native, others brought from China during the Edo Period. They range from the massive *madake* lumber bamboo to chic *kurochiku* black bamboo, and pliable *nemagaridake* rattan.

Bamboo's properties are mind-boggling: light, flexible and strong, it can be used whole or divided into almost infinitesimal parts. Hollow but for the joints, it can also hold liquid, and is used to make everything from household implements to farm tools, furniture, fishing tackle, weapons, and musical instruments.

Bamboo's versatility is reflected in its use by both the most skilled artists and basic craftsmen. The former will turn it into stunningly intricate, woven artworks, while the simple products of artisans display unaffected, natural beauty. For permanent works, fine artists use cured bamboo that has had the oil removed—an unnecessary process for more functional baskets, for example, which are meant to be used and replaced.

There is a story that the celebrated tea-master Sen-no-Rikyu was once so besotted by a fisherman's woven bamboo creel that he begged it from the man. The tea master was taken by the organic beauty that arises from the pursuit of pure function over artistic concerns, and his fascination with such articles led to bamboo's hallowed place in the tea ceremony, where it is used for tea scoops, whisks, and ladles.

The proliferation of bamboo has meant regional craftsmen use their local indigenous strains to create area specialties. Southern Japan around Beppu, for example, is home to a hearty strain of madake lumber bamboo, used for modern living-room furniture as well as implements for tea ceremony. Gifu, in central Japan, turns its forests of flexible madake into the ribs of umbrellas and lanterns.

The best bamboo artworks emphasize the essential qualities of this amazing plant: a life-like warmth and pliancy that cannot be duplicated by any man-made material.

SUSUTAKE BED

Naotomo Inagaki

Traditionally, bamboo was smoked by being held over a fire until it turned a rich, dark brown. But with eyes that discern the true characteristics of his materials, Naotomo Inagaki finds his *susutake*, also known as "soot bamboo," in the roofs of Edo-period farmhouses, where it has been deeply colored by decades of smoke from *irori* hearth fires. Crossed bamboo pieces were used as support under the thatched roofs, and were bound with hemp, leaving uncolored those areas untouched by smoke. Inagaki carefully creates his designs using the contrast of light and dark areas, along with the intriguing marks left by the chopping tools of a century ago.

On this bed, surprising patterns are formed from head to foot where the lighter areas left by the binding stand out against the mottled dark brown. Because the binding marks are in a different place on each piece of bamboo, only a few will fit just right, and Inagaki uses all his skills to adjust them.

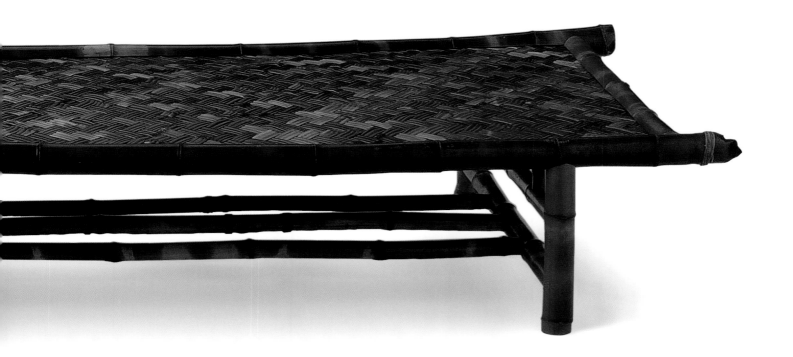

KNIVES AND FORKS

Naotomo Inagaki

Inagaki chooses his bamboo for these unusual utensils for two characteristics: shape and color. He makes sure that each finished piece will include a bamboo joint and an area where bindings, over the years, have left the bamboo unsullied by soot. The combination of qualities gives each utensil a powerful presence and distinctive look. In some, insect damage has rendered some portions unusable, so he carefully cuts those parts away, giving the piece a unique, organic shape.

When he makes these implements, Inagaki first empties his mind, exorcising the normal shapes of forks and spoons, then allows his hands and tools to seek their own direction. His hands move naturally, scooping a bit from between the lines of the joint to enhance its beauty. Inagaki knows the bamboo, and believes it can tell him of the shapes hidden within.

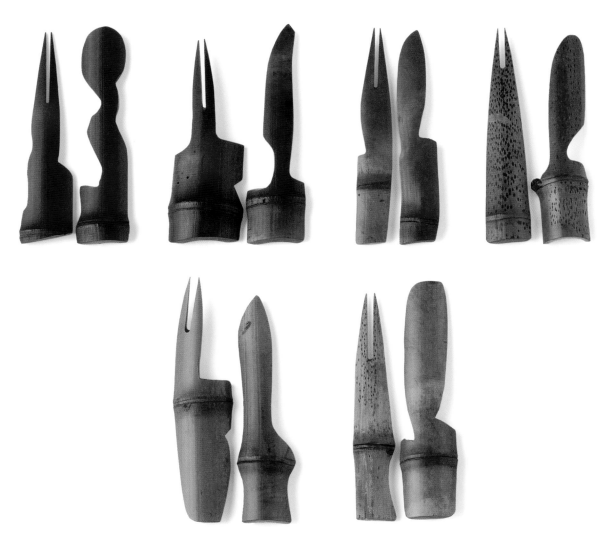

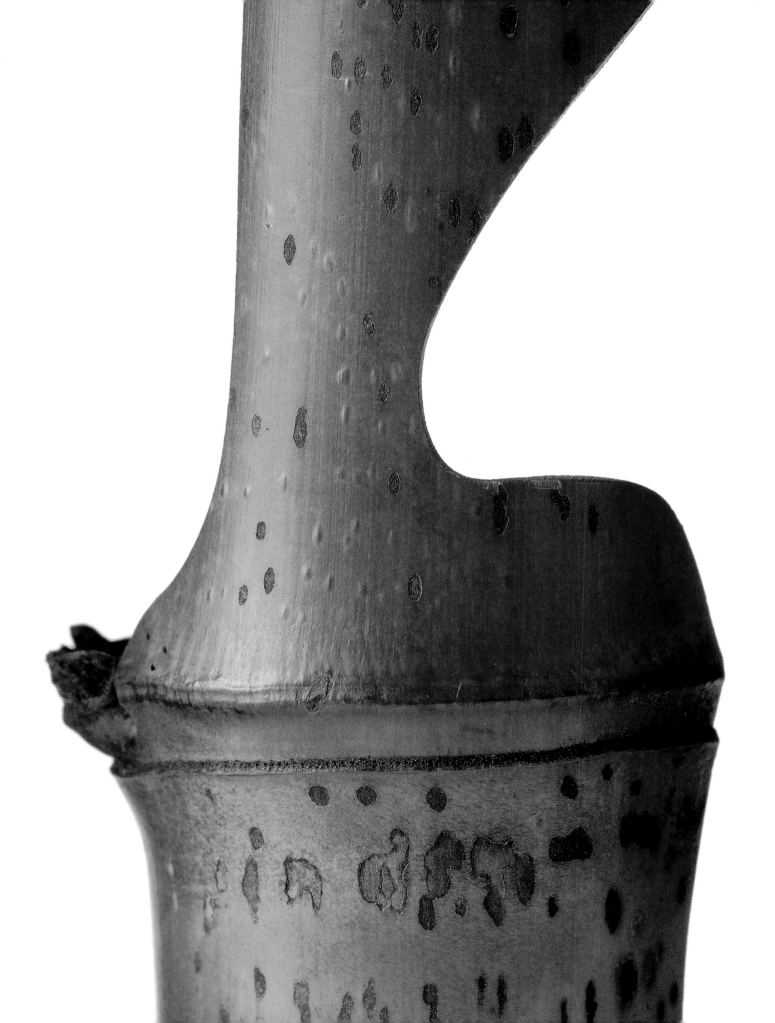

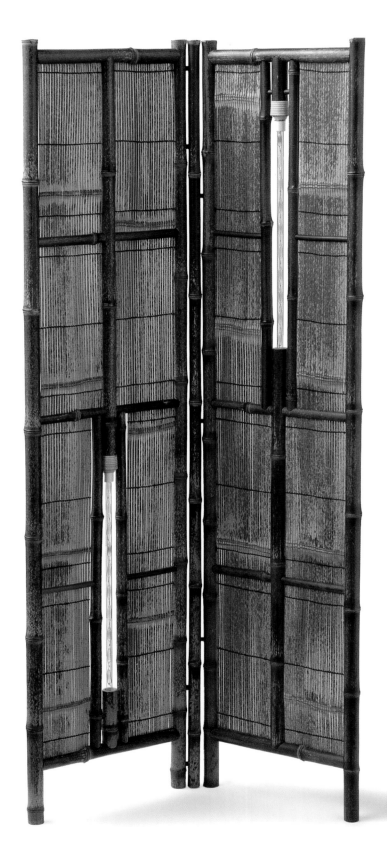

SCREEN LIGHT
Toshiko Kawaguchi

Architect Toshiko Kawaguchi's father ran a Japanese furniture atelier. She credits the traditional feel of her modern designs to the appreciation she acquired for the beautiful natural materials she found there. This entire screen light is made of black bamboo; frames and delicate interior panels alike. Each interior panel segment is made of a single cane of bamboo, carefully split and tied so the joints form lovely lines across the face.

The screen's folding design is a marvel of traditional craftsmanship. The left wing is fastened above the first joint and below the fifth by four dowels; the right wing is attached with three dowels below the first and above the fifth joint. The central cane is severed (the cuts are almost invisible) at the first and fifth joints, and traditional wooden *karakuri* hinges are inserted to allow the screen to open and close smoothly. This simple, durable design, which uses only natural materials, reveals an intriguing synergy between architecture and craftsmanship.

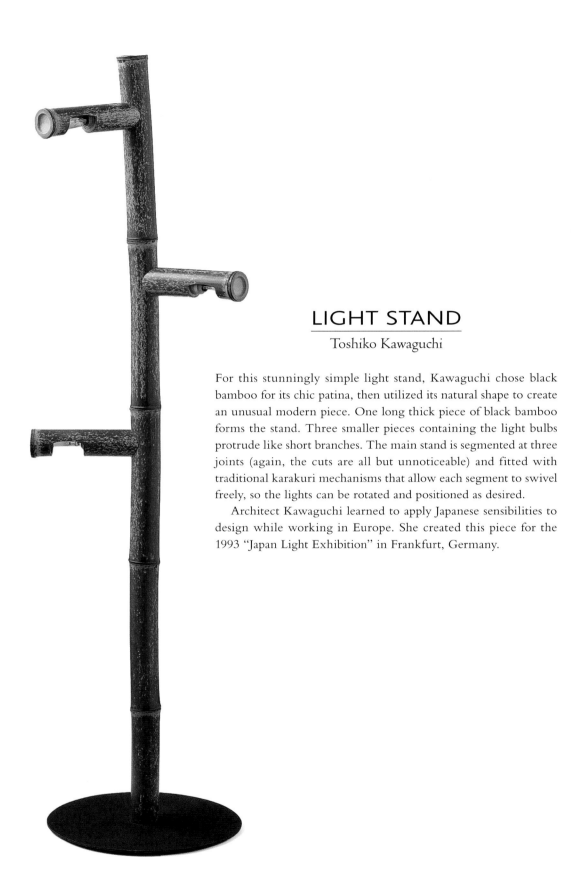

LIGHT STAND
Toshiko Kawaguchi

For this stunningly simple light stand, Kawaguchi chose black bamboo for its chic patina, then utilized its natural shape to create an unusual modern piece. One long thick piece of black bamboo forms the stand. Three smaller pieces containing the light bulbs protrude like short branches. The main stand is segmented at three joints (again, the cuts are all but unnoticeable) and fitted with traditional karakuri mechanisms that allow each segment to swivel freely, so the lights can be rotated and positioned as desired.

Architect Kawaguchi learned to apply Japanese sensibilities to design while working in Europe. She created this piece for the 1993 "Japan Light Exhibition" in Frankfurt, Germany.

WAVE BASKETS

Kazuyuki Kubo

Kazuyuki Kubo says he finds much of his inspiration for shapes from nature, yet often discovers that, after a mere twelve years as a weaver, his hands lack the necessary technique to reproduce what he sees in his mind's eye. This is obviously not the case with these baskets, which, according to the weaver, mimic waves of ripened rice as the wind blows across the paddies.

The waves made by the weave of these baskets undulate twice, forming three pockets so three different dishes can be served at once. A simple result, but a difficult task: Kubo relies on traditional techniques, but his solutions are unique.

CALLIGRAPHY BRUSH

Hirokazu Tazaki

Hirokazu Tazaki's love affair with bamboo drew him to create tea ladles and paper from its fibers. To match the bamboo paper, he found himself looking for a stiffer kind of brush, and found his solution in the blunt squared brushes of bamboo that have become his trademark.

Tazaki harvests bamboo shoots when they first appear in spring. He beats the solid root with a wooden mallet, breaking it into fibers, which he then combs with a steel-toothed implement. The process is repeated until the fibers of the root have become delicate enough to act as the brush's bristles. These unique brushes offer the strength of long-joint bamboo and the simplicity of nature; nothing is added and nothing taken away.

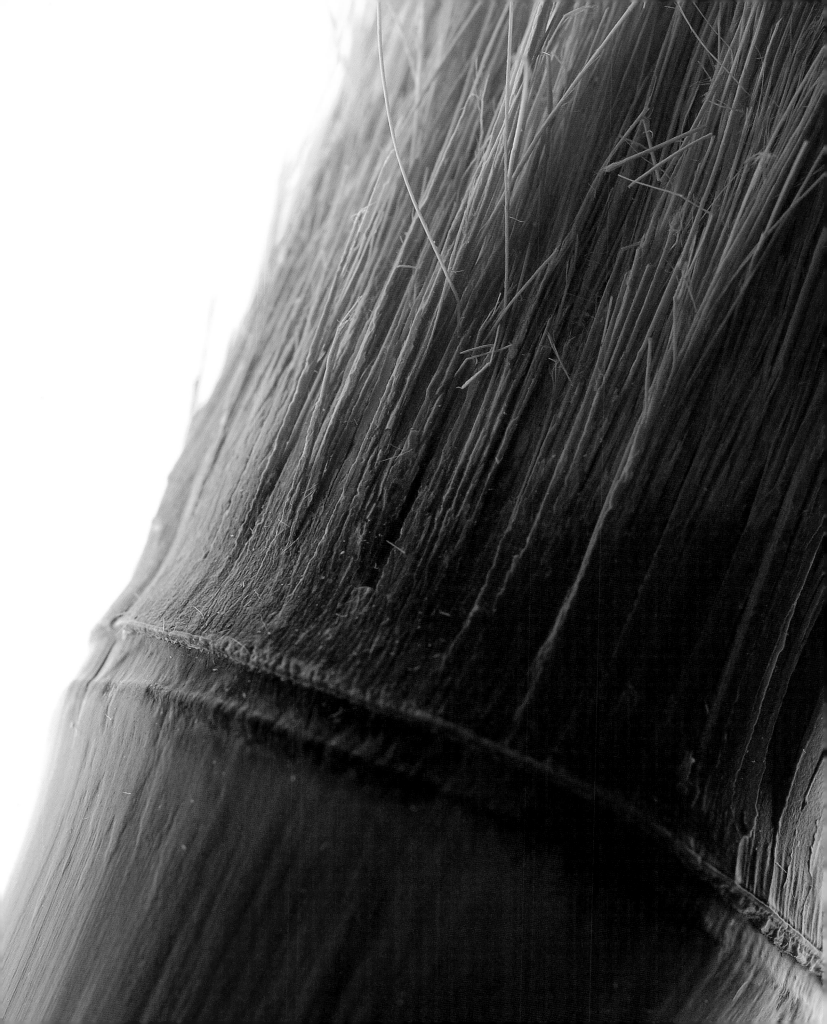

METAL

Metalware has been vital to Japanese life since the bronze-age Yayoi Period. Today, artisans still use traditional methods, including casting molten metal in sand and clay molds; working with hammers and anvils to create pieces wrought of brass or copper; and sculpting—gouging and cutting from solid blocks.

Enthusiasts of cast-ironware can savor the best pieces at tea ceremonies held in *chashitsu* tea rooms. First to catch the eye as you enter such rooms is the cast-iron kettle, boiling water on a cast-iron hibachi; the sound of steam like a breeze blowing through pines.

In any tea house, it is likely the kettles are from Morioka in Iwate Prefecture, where the cast-ironware is known as *nanbu tekki*, or "southern ironware." During the Edo Period, Morioka was the castle city of the Nanbu domain, and for many generations the regional lords were deeply involved with the tea ceremony. Legend has it that one of the Nanbu lords demanded a teapot made of iron instead of the traditional pottery, and the result was the first of what would become the famous nanbu tekki teapots. For centuries, the sand molds for these vessels were made by hand, but modern casting techniques allow mass production of equally fine pieces.

In Japan's not-so-distant past, every home had a ceramic hibachi in the living room, with a cast-iron teapot hanging over the charcoal fire, full of hot water and ready to brew tea. But in the post-war years, as homes gradually became Westernized, the hibachi disappeared—its place taken by gas ranges—and the cast-iron teapot was almost completely supplanted by vessels of aluminum or stainless steel.

Fortunately Japanese have rekindled their love of cast-ironware, with good reason. Water heated in iron absorbs small quantities of the health-giving mineral, and new works by modern artists have caused a stir as increasing numbers of people have come to appreciate the beauty of high-quality cast iron.

Other metal-working techniques and materials have also acquired a certain cache, including wrought iron, brass, and silver. In Europe and other Western countries, silverware tends to be highly polished and decorative. But in Japan, matte finishes and simplicity are the norm.

Japanese metalworks—like other traditional arts—tend to be understated, with sensual curves and what might be described as a soothing aura. Despite their minimalist forms, we often find in these pieces vivid textures that could only come from a rich history of metalworking.

IRON KATAKUCHI AND SAKE SERVER

Hisao Iwashimizu

Hisao Iwashimizu has always been intrigued with the forms and textures of Muromachi-period *raku* ware—pottery made by coiling ropes of clay rather than throwing it on a wheel. This is the pottery favored by Japan's greatest tea master, Sen no Rikyu; the pottery that beseeches you to pick it up, to feel its sensuous fired surface. Iwashimizu's fascination with raku pushed him to look for ways to create cast-iron utensils with similar qualities. Further inspiration, he says, came with the birth of his baby daughter—the revelation of her tiny bottom, and irresistibly kissable face.

For some time, Iwashimizu worked on new methods and shapes until finally he hit upon polishing the cast pieces. This removes the dimples and roughness left by the casting sand; since no two pieces are polished alike, each, of course, becomes unique. Then each piece is tempered again to create special patterns and textures unlike those of any other ironware artist. The works below shaped like baby chicks are versatile *katakuchi* pitchers, most often used for serving sake. The piece with a handle and lid is specifically for sake.

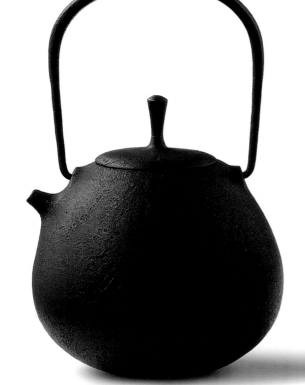

IRON SAKE SERVER

Hisao Iwashimizu

Because Iwashimizu wants everyone to share his passion for iron, he strives to create works that fulfill their users—works that offer a feeling of relaxation and peace, yet effuse a certain artistic tension.

His idea for this server came from a desire for a special kind of vessel to use when sitting with friends on a cold night, drinking sake warmed to skin temperature. He claims sake tastes better when warmed in iron because the metal transfers heat quickly and evenly—though he is quick to point out the vessel can also be used for serving chilled sake. He made the server perfectly round—like the full moon—to facilitate easy, tea ceremony-style conversation.

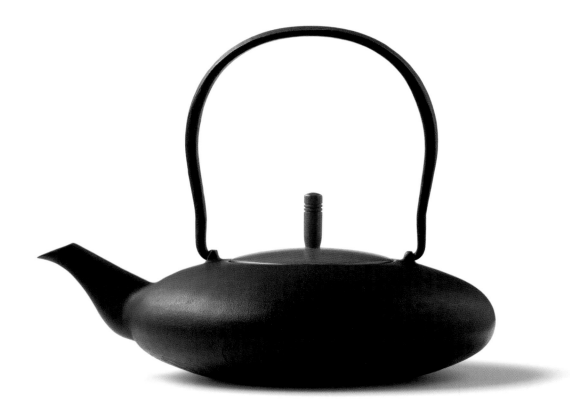

IRON BOOKENDS

Rikucho Ogasawara

Rikucho Ogasawara is a second-generation founder from Mizusawa, a city in the northern prefecture of Iwate that specializes in cast-iron pots, kettles, bathtub heaters, and other common items. He learned casting aesthetics and techniques from his father, who studied the craft in Morioka, home of Japan's most famous cast-iron teapots and kettles.

By nature, iron is hard and cold. But Ogasawara believes it can be molded and coaxed into shapes that, while simple, appear to breathe. He also believes that everyday ironware should have a gentle nature.

He takes inspiration from his surroundings—even pebbles in streambeds can provide design ideas. Once he watched a cow chewing its cud, and modeled one of the bookend sets below after her horns. The work on the right, called "Bookend F," resembles the flat symbol in musical notation—and expresses his love for Chopin and Mozart. His designs are based on such ordinary observations, he says, he is sometimes embarrassed to reveal them.

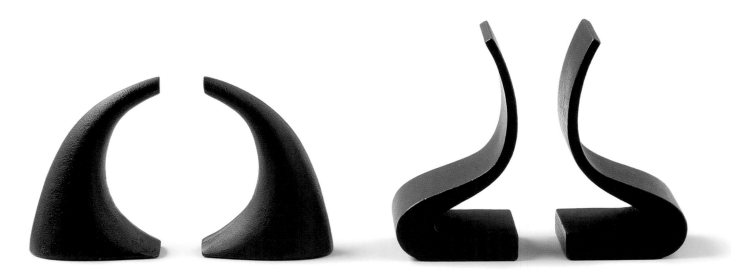

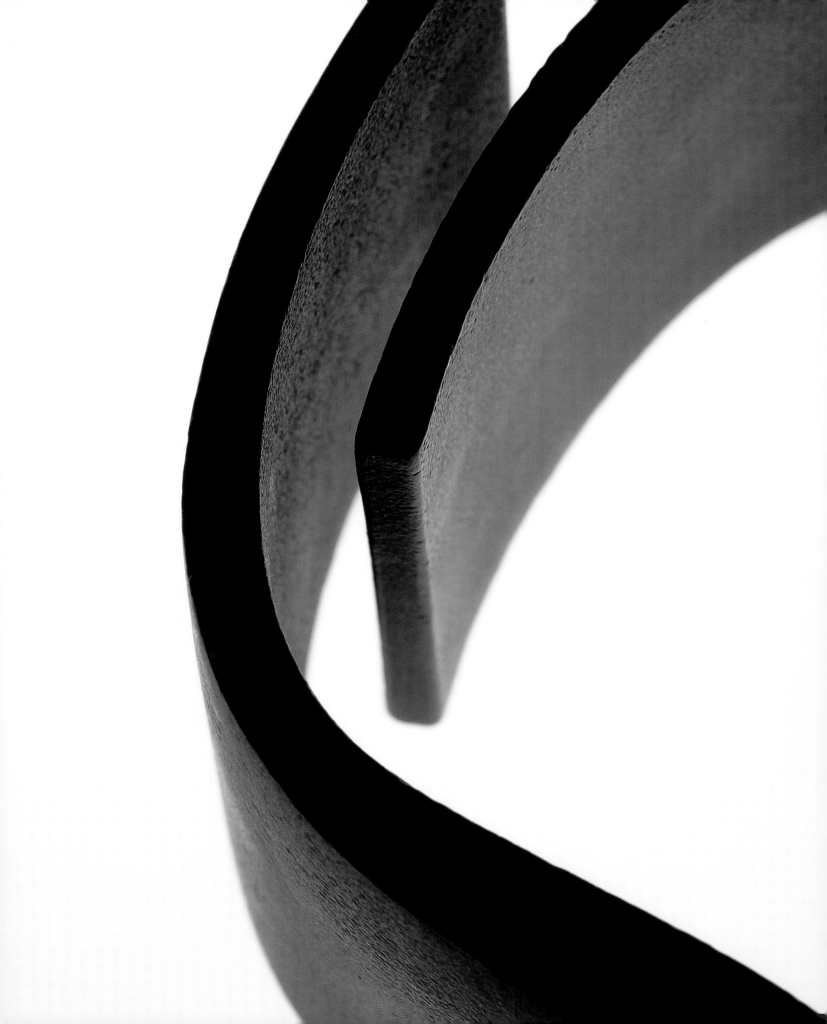

SILVER-PLATED VESSELS

Mizuko Yamada

Artistic wrought-metal techniques can turn materials such as copper and silver into almost any shape. Mizuko Yamada seeks to create works of "tactile form," tapping and squeezing from her metals a texture that you can feel just by looking at them—it's not even necessary to pick the pieces up.

While working in Europe, Yamada watched those silversmiths making traditional silverware struggle to make each item of a set exactly the same. But she found herself identifying more closely with Japanese pottery aesthetics—in which each part is distinct, differing from the others if only in minute detail—and her silverware now follows this pattern.

The pearlescent white on these three pieces occurs naturally when copper is electroplated with ionized silver. Ordinarily, the artist polishes the piece to remove the white and bring out the silver finish, but Yamada feels that since her work is, in truth, silver-plated copper, the distinctive white hue should remain. After all, she reasons, pure silver items cannot replicate the unique look of these pieces, and since they are less labor intensive to produce, their beauty is obtainable at a more reasonable cost.

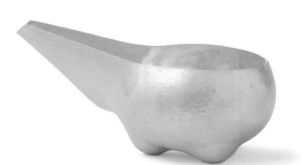

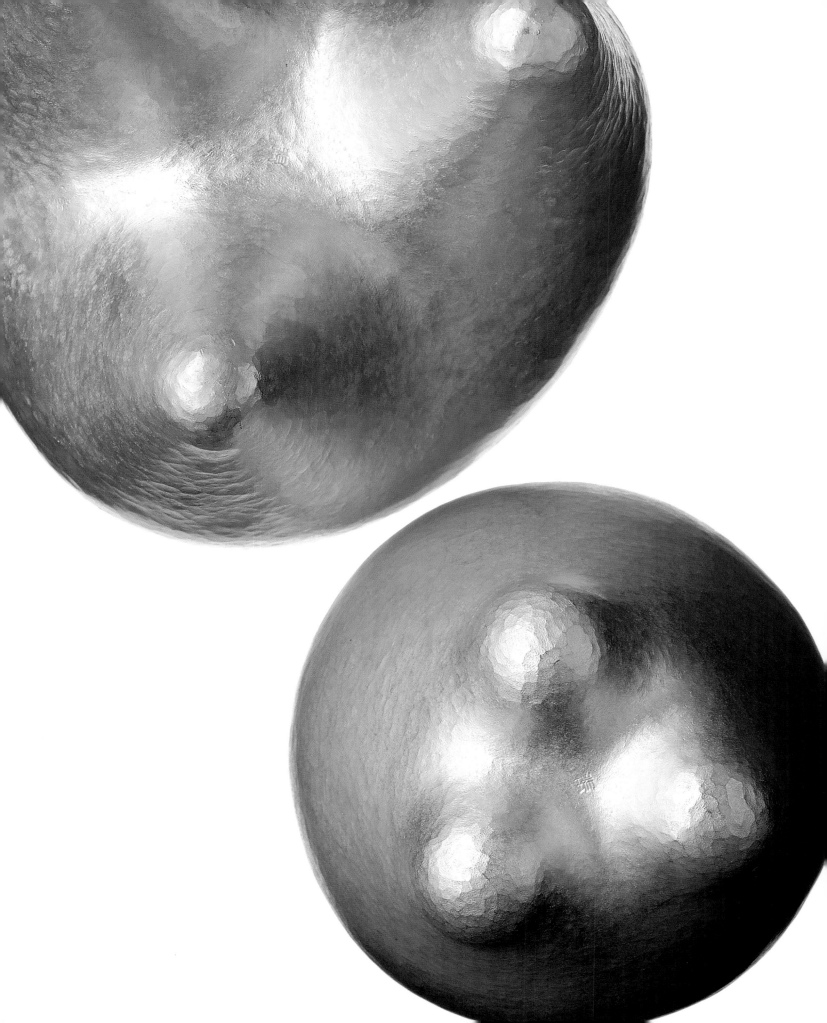

IRON
CANDLEHOLDER

Kozo Takeda

Once upon a time . . . according to the folk tale *Kachikachiyama . . . an old man and his wife lived quietly in a mountain hut. . . .* Many Japanese who remember this opening may have forgotten what follows, but will doubtless recall the appearance of an evil raccoon dog and, on his back, a fiercely burning bundle of *akebia* stalks. When Takeda chanced upon some akebia one day, he was reminded of the story and inspired to design this candleholder.

The handful of akebia stalks with the candlestand atop it passes through the cubic iron frame, and because the tightly bound stalks grip the legs of the frame, the candle can be raised or lowered to any preferred height. Takeda chose to have the ironwork hand-beaten by a craftsman rather than machine-tooled. This assures an imperfect, human touch and gives the work its distinctive character.

BRASS VASES
Miho Nishikawa

Metalworker Miho Nishikawa raises birds, from whose shape and activities she takes inspiration. Her affection for her pets is evident in these pieces, conceived when she watched sleeping chicks huddled near her work bench, apparently secure in her nearby presence.

These globular vases with their pouting holes on top are wrought from brass. Each begins with one sheet of the metal, which is placed against a spherical anvil and lightly tapped many hundreds of times with a hammer until it expresses the desired shape. A torch is then used to create the uneven edge around the opening. The final task is to create the base, which is made from a separate sheet of brass and soldered to the body.

Nishikawa says the most difficult step is deciding when the brass has been shaped to her satisfaction: choosing the proper moment to quit. The most critical stage is melting the metal around the opening just enough to create the rough lip.

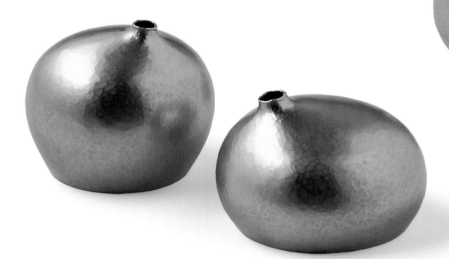

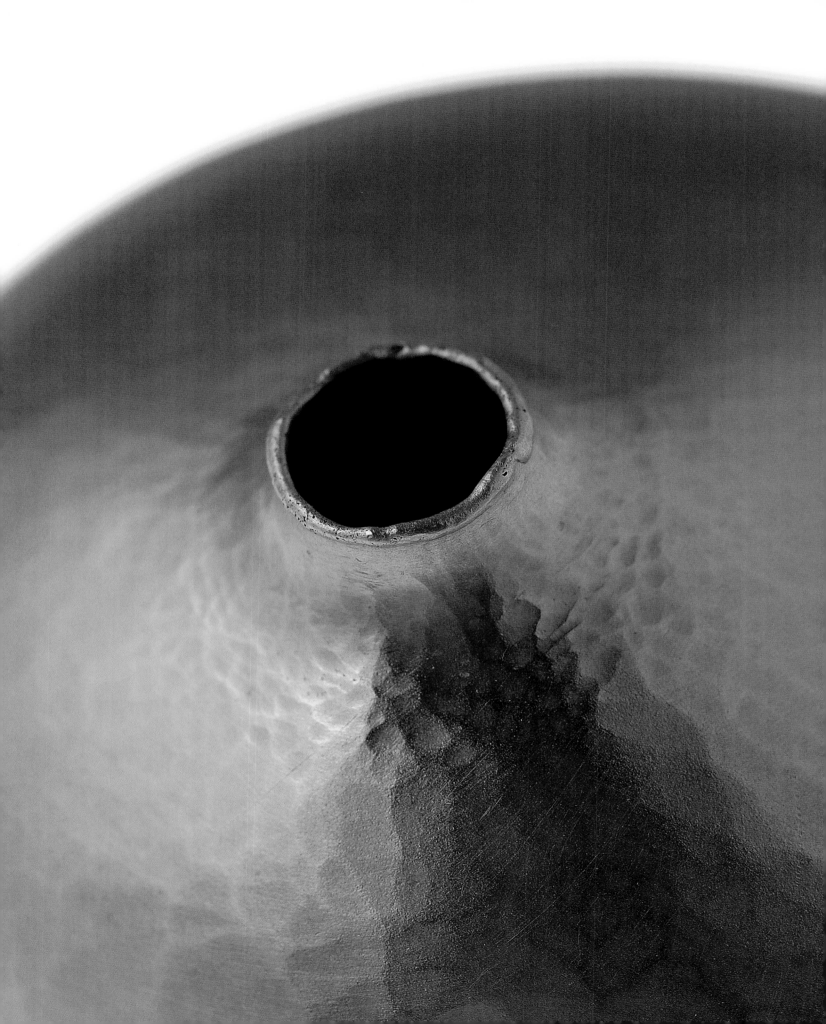

IRON KETTLES

Hiroyuki Nagashima

The handles of traditional cast-iron pots and kettles have always been a complete semi-circle, shaped to hang on pothooks over the fire. The pothooks, called *jizai*, extended to the ceiling over charcoal fires in sunken hearths, and the high-arched handles made an easier task of hanging and removing the vessels as they were reset to the proper height over the fire.

Now kettles are used on kitchen ranges, pothooks are nonexistent, and there is no longer a need for enclosed handles. This tempted Hiroyuki Nagashima to make these unique kettles. The graceful curve of their half-arched handles is not only visually striking, but makes it easy to remove lids and replenish water. The knobs on the lids were made to resemble the new buds of spring, and the handles were meant to look like strong blades of young grass. Nagashima says that he imagined, as he worked, shoots bursting from the earth and growing upward with vigor. The bases of the handles are wedge-shaped, created in collaboration with traditional cast-iron founders.

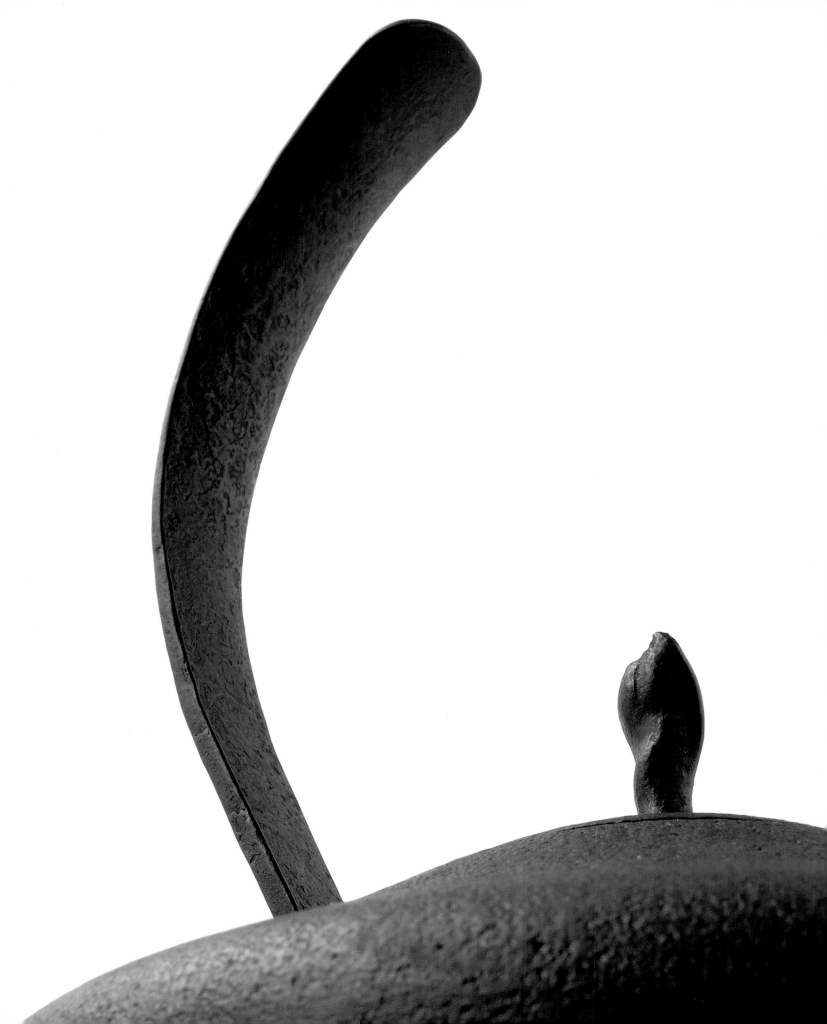

WASHI

Often called "Japanese paper," or, mistakenly, "rice paper," *washi* is made from the fibers of various plants—none of them rice. These include the inner bark of *kozo* (paper mulberry), *mitsumata,* (related to the chrysanthemum), *asa* (hemp), and wild *ganpi* (*diplomorpha sikokiana*), which is almost impossible to cultivate.

Washi-making methods have remained the same for centuries. Once the whitish inner fibers of the plant are boiled, water and a vegetable mucilage called *neri* are added and the pulp is shaken to achieve a consistent texture. A fine layer of the mixture is then scooped in a tray-screen, and the process is repeated until the pulp is the desired thickness. The wet sheet is transferred to a special board on which it is stretched and sun-dried.

Originally washi was used mainly for official documents and the copying of Buddhist sutras. Then artists and carpenters adopted it. Both translucent *shoji* doors and the more solid *fusuma* doors are covered with types of washi, while lacquer craftsmen made containers by coating shapes of molded, layered washi. The paper is also crumpled and sewn for clothing, or twisted and used as thread. In fact, samurai (and sumo wrestlers) used strings of washi to tie their topknots. Even toys are made of the magical material.

In the Heian Period, as many as forty-two Japanese regions made washi. Demand peaked in the Meiji Period, when the population of paper makers reached 200,000. But the advent of cheap, machine-produced paper from the West saw this number fall rapidly, and by 1984 there remained fewer than 500 washi-producing households.

Yet the tradition has continued. Recently, Ichibei Iwano, a washi craftsman in the Echizen Hosho tradition, was declared a Living National Treasure, and *Nihonga*—Japanese painting—artists prize his paper. In Europe, translucent *gampi washi* is used as a safe, non-toxic backing for priceless scrolls, paintings, books and other artworks during their restoration. Meanwhile, an increasing number of artists is finding the creative horizons of washi to be limitless, and appreciation for this extraordinary material is growing.

TAPESTRY

Kazuyuki Tomi

One of Kazuyuki Tomi's intentions is to create artworks using only natural materials. The other is to imbue his work with lightness and richness. With this tapestry, he has made a piece that seems to float like cotton, blowing in the wind.

Tomi created this work by painstakingly tossing the traditional mulberry fibers used in *washi* paper-making so that they caught on the cotton threads he laid randomly as a base. Then he anchored the piece top and bottom with smoked bamboo, taken from beneath the thatched roofs of Edo-period farmhouses. The weight of the rich brown, achieved over decades (perhaps centuries) in the smoke of farmhouse cooking fires, offsets the lightness of the new, pure paper. The result, like many of Tomi's creations, invites us to reach out and touch it.

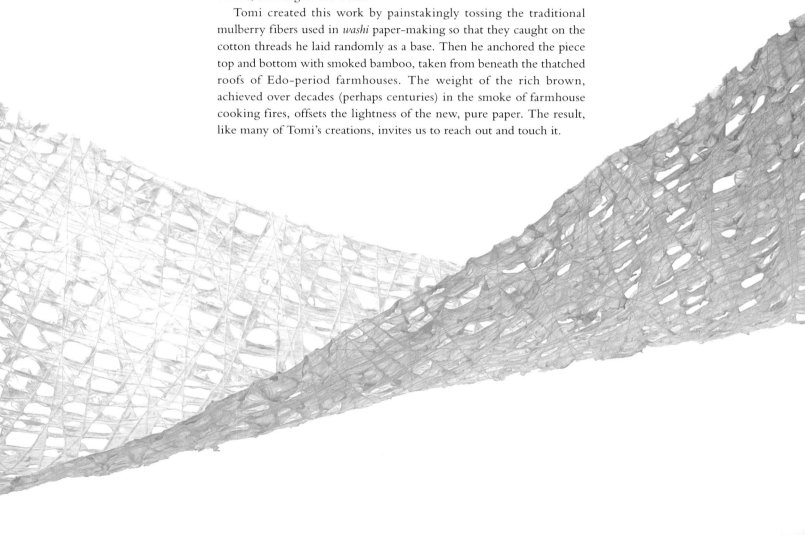

BRANCH LIGHT

Kazuyuki Tomi

Again, natural materials and lightness are Tomi's themes. With this lamp he wanted to convey a sense of floating clouds. The materials he used are washi paper and bamboo grown near his atelier.

The framework is of tied bamboo branches and twigs. The handmade washi is dyed a subtle green with chestnut husks, then rubbed by hand to increase lightness and volume. To make the dome-like shade, Tomi covers the bamboo with two sheets of washi, taking extra care to make the join imperceptible. When the lamp is lit, the tint of the paper adds to the shade's richness, and the bamboo framework is revealed in a beguiling silhouette.

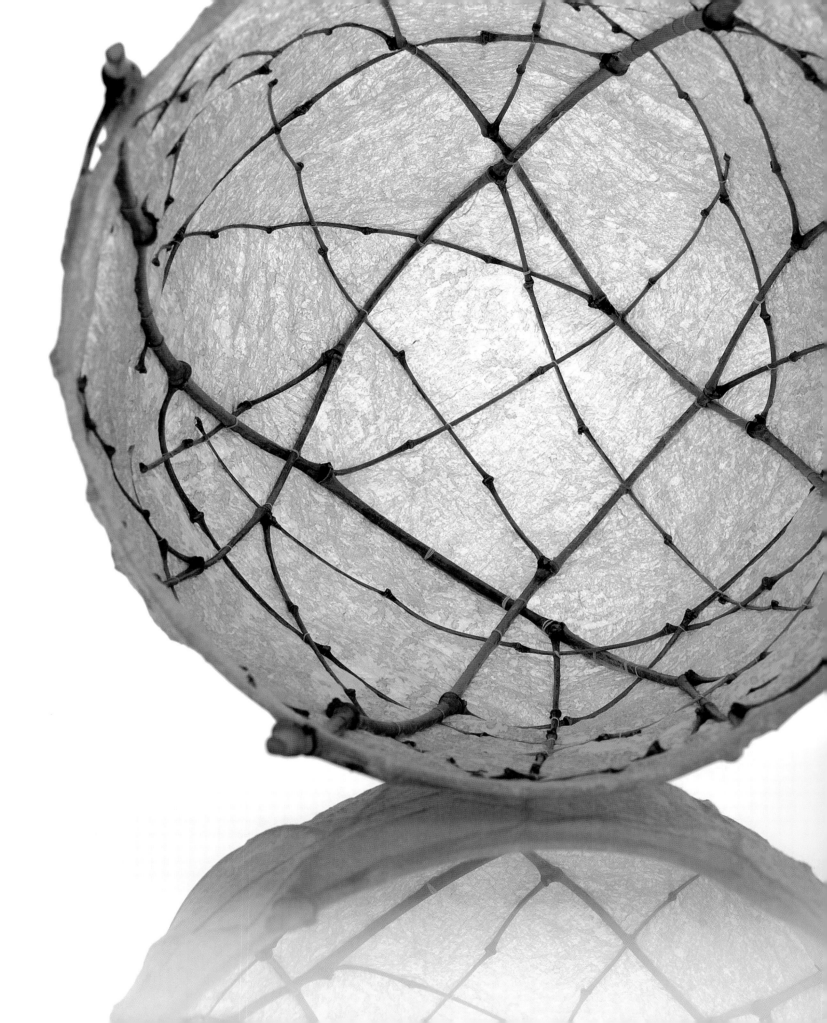

GIFT ENVELOPE AND CHOPSTICK WRAPPING

Origata Design Research Institute

Origata describes traditional methods of wrapping Japanese gifts in washi, using special folding techniques developed over the centuries, predominantly by families of the warrior class. Recently, a group of designers, calling themselves the Origata Design Research Institute, set out to learn everything they could about these paper-folding methods, and to build on them to create modern techniques. The group sought designs that communicated the feeling behind a gift, and in their search came across *Minogami*, a type of washi made in Gifu Prefecture. They found it ideal for folding, and worked with young papermakers from the area to develop a type of Minogami on which to base a new school of origata. Two successful design examples are these chopstick wrappers and money envelopes.

In Japan, gift money for weddings and other celebratory occasions is traditionally wrapped in red-and-white colored envelopes. The institute's new approach shown here uses one sheet of translucent white paper in combination with another sheet of red paper. When perfectly folded, the red shows through in elegantly graduated colors. The same Minogami used to enfold the willow chopsticks used at New Year's also balances white and red, reflecting the festive occasion.

KOYORI CONTAINERS
Ryoichi Kobayashi

One ancient Japanese craft consists of putting paper over wooden forms and wetting it with lacquer to create sturdy containers. But the revolutionary method used here is more complicated: tightly rolled paper strings called *koyori*, instead of single sheets of paper, are wrapped in a roll and glued together to create a circular sheet of material. The resulting forms are stronger and more elegant than the single sheet type. Hardened by coats of lacquer, under Ryoichi Kobayashi's direction the sheets are cut and folded to become boxes, trays and other containers inspired by origami: the craft of folding paper into cranes, other birds and animals, and familiar objects. Incredibly, each of these pieces was made of one string wound into one piece of "paper."

For these pieces, Kobayashi combines three traditional crafts—koyori, origami, and lacquer—in avant-garde shapes, bringing consistent quality and elegance to every piece.

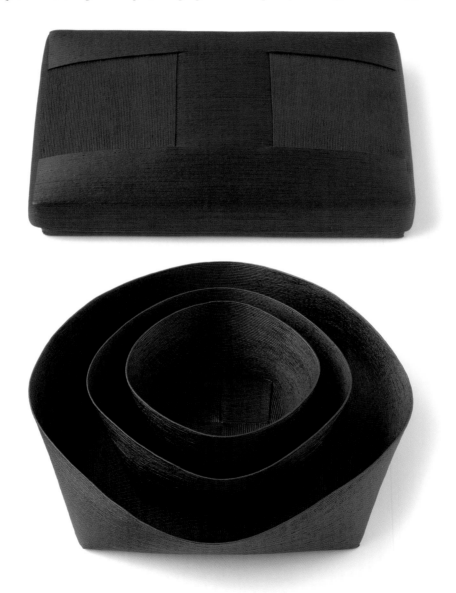

LIGHTING OBJET

Eriko Horiki

Washi interior design specialist Eriko Horiki was approached by Kanose, a small town in Niigata Prefecture, for ideas to boost the regional economy. During her research, she noticed the township's eight hydroelectric power plants; she also found that Kanose grows paper mulberry trees, whose leaves can be turned into washi. Her suggestion was to make a a product that combines electricity and paper. At that point, Kanose had no history of traditional paper producing, so Horiki knew the product had to be a simple one. Many of her previous works were made using a unique method she developed for making three-dimensional shapes, and she offered this method for use as a way of supporting the locality. A new regional industry was born around these globular lights.

Horiki's simple paper-making method is easy for a new generation to learn, which she believes will ensure continued production. She also hopes that awareness of these lights abroad will raise the profile of the small town from which they come.

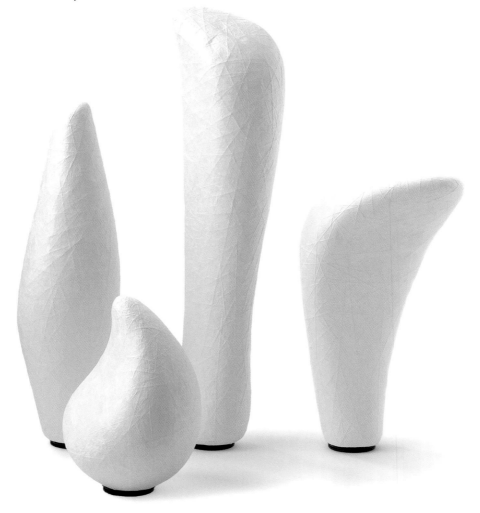

FOLDING SCREEN
Sachio Yoshioka

This *byobu* screen, with its varied shades of gray, looks like an abstract work of art. But Sachio Yoshioka calls it a *suiboku* ink-painting rendering of a Kyoto winter scene.

Yoshioka, a fifth-generation Kyoto dyer, draws inspiration from the seasons and changing scenery, and uses vegetable dyes to create contemporary colors. He also researches ancient documents from the Heian Period for ways to reconstruct the dyes used in clothing of the time. He uses only the best *sumi* ink: soot mixed with *nikawa* glue and allowed to age for at least half a century. Only this old sumi, in which the glue has completely dried, creates the lambent colors Yoshioka demands. For Yoshioka's screens, a respected washi craftsman in Izumo makes the paper and another craftsman in Tokyo makes the frames. This work is a close collaboration between three traditional craftsmen.

WOOD-GRAIN STATIONERY

Yoshifumi Okatsu/Yuko Yokoyama

Yuko Yokoyama has spent much of her career introducing Japanese culture and craftsmen overseas, and her meeting with Yoshifumi Okatsu led to a unique collaboration between producer and craftsman.

Most washi of today, even the handmade type, is mechanically dried. Okatsu, however, is one of few craftsmen to keep to traditional methods: he spreads out his washi sheet by sheet in the sun. This process leaves a three-dimensional grain in the paper from the wood it is laid upon—and the paper takes on a soft, rich texture. At the time of the meeting with Yokoyama, Okatsu was making only the traditional long and narrow Japanese envelopes, but smitten with his work, Yokoyama convinced him to expand into Western-style envelopes and folded stationery. Still, as the work is governed by the weather, mass production is impossible, and its scarcity—and the fact that no two pieces are the same—enhances the product's value.

LACQUER

This unique substance, from the sap of the *urushi* lacquer tree, was developed by the ancient Japanese to protect and decorate fired clay containers. As techniques improved, lacquer also was used on utensils of wood, bamboo, fabric, leather, paper, and metal. During the feudal ages, lacquerware items became highly prized by the imperial family, the shoguns and domain lords, and when the tea ceremony matured in the sixteenth century, lacquerware found a place there as well. The finest lacquer techniques were used to produce Buddhist statues for temples.

Production flourished under the Tokugawa shogunate during the relative peace and affluence of the Edo Period, and certain regions became renowned for their artistry. Distinct variations include the *maki-e* designs of *Wajimanuri,* from Ishikawa Prefecture; *Tsugarunuri*, from Aomori Prefecture, in which multiple layers of green, red, yellow, and brown lacquer create a spotted-marbled effect; and *Shunkeinuri* from Gifu Prefecture—clear lacquer emphasizing the natural wood grain.

Among the basic lacquer techniques are *fukiurushi*, a method of using clear lacquer over natural wood; *tamenuri*, another clear lacquer; *kuronuri* black lacquer; *shunuri* red lacquer; and *negoro* marbled red-over-black lacquer.

As production increased, lacquered bowls began to appear on commoners' tables, but facing the increasing spread of ceramics and pottery, it was generally reserved for special occasions—a custom that persists in the use of stacked lacquered food boxes during today's New Year's festivities.

Nevertheless, lacquerware has its place at everyday meals. Few families would consider serving *miso* soup in anything but a wooden lacquered vessel—since Japanese soups are meant to be sipped from the bowl, the insulating properties of wood mean the edge of the bowl never burns the lips. Further, the wood tempers the heat of the liquid to the perfect drinking temperature.

Versatile artists today apply lacquer not only to wood, but myriad base materials. Its continuing appeal rests on its lustrous feel, its range of colors—from striking hues to the subtlest tones—and its strength. Lacquer protects and preserves, and does the job so well that fine lacquer items are passed down for use through generations.

ORNAMENTAL BOWLS

Seiichiro Fujino

Artist Seiichiro Fujino says he was attracted to lacquerware because, unlike crafts such as ceramics or glassware, it is always the result of a "collaboration between different materials." It is this fusion that gives lacquer its ever-original and diverse appearance.

In his work, Fujino focuses on the "relationship between what is inside an object and what is on the surface." This series of ornamental bowls is titled "Flower," a word that conjures a surface image, while the works invite us to ponder what is beneath. As in his other pieces, Fujino used *kanshitsu* techniques—starting with a core of wood and steel, then applying fibers and wood flour mixed with lacquer and wrapped with cloth—to form his startling shapes. True to the artist's intent, lacquer may be the outer coating, but something else entirely lies within.

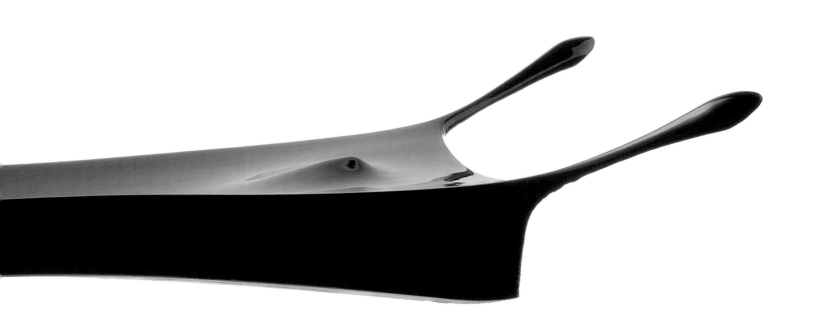

One piece of the Flower series (TOP) was made with the *negoro* technique of coating the black base coat with red. The red lacquer is applied thinly in places to expose the black. In the last piece of the series (BOTTOM AND COVER), Fujino has left his chisel marks in the wood, resulting in a visual "collaboration" between the unfinished wood and the lacquer, and underscoring the shape of the bowl.

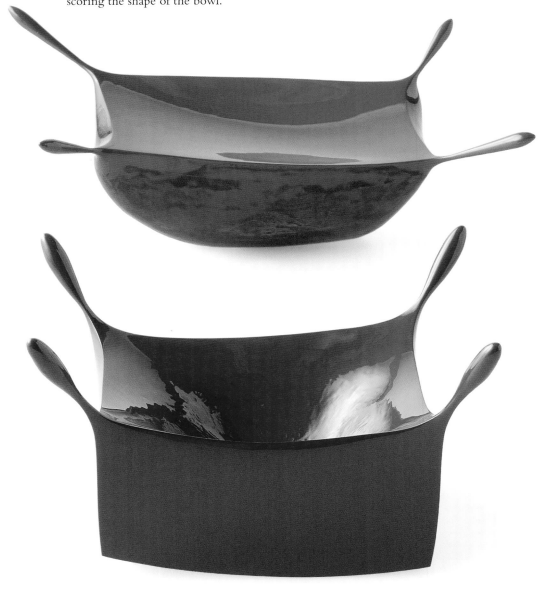

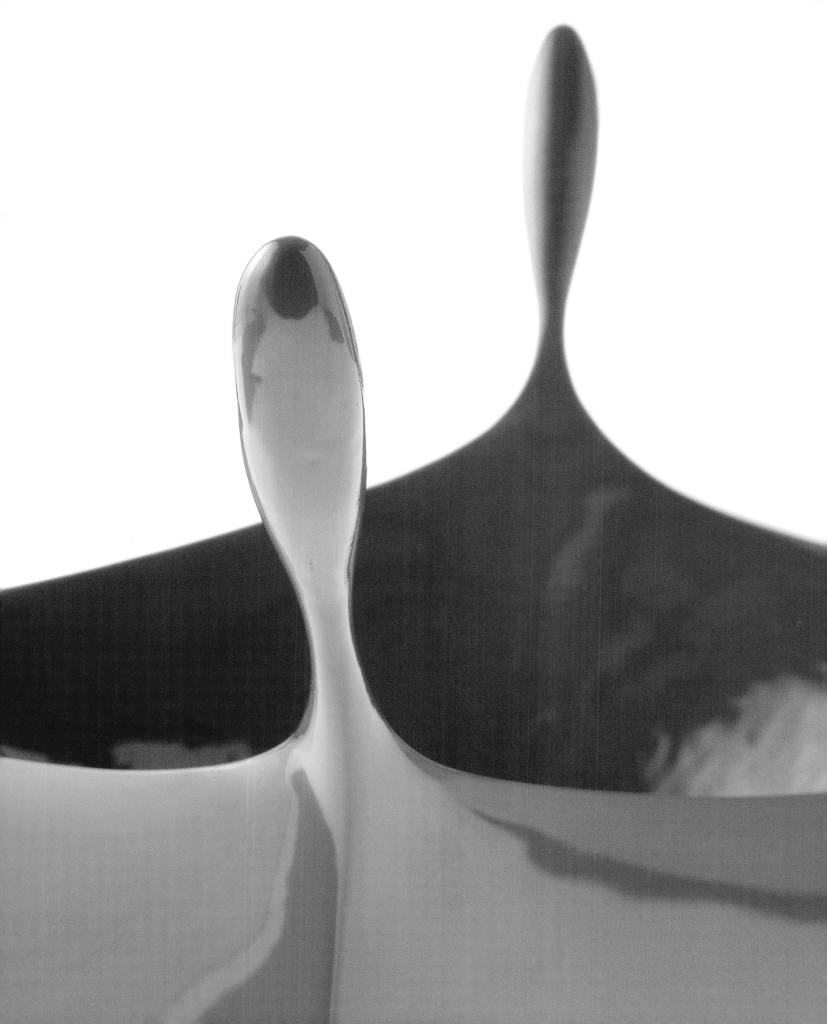

STACKED DINNER BOXES

Yasuyo Izumi

Stacked food boxes, or *jyubako*, are what the name implies—one lid over several boxes stacked on top of each other. Traditionally, jyubako are square; they also tend to be finished in red or black lacquer, or with gold *maki-e* decoration. But Yasuyo Izumi is not tradition-bound; she saw no reason why her boxes couldn't be triangular, or finished in subtle graduated monotones.

She also altered the way they are used. Conventionally, jyubako feature one dish per box, and all boxes are opened simultaneously to allow diners to select a portion from each. But Izumi doesn't look on the boxes as big serving dishes. Instead she puts one person's meal in each box. The result is a different kind of dinner plate for her guests. Serving up to seven, her stacked boxes reflect both her previous career as a graphic designer and her personality as one who loves entertaining.

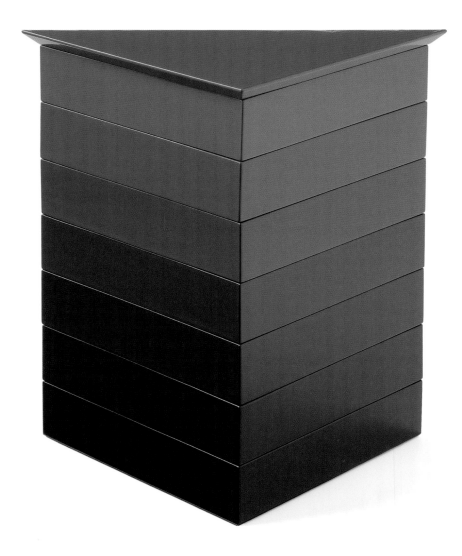

COLOR TRAYS
Makoto Kawamoto

These colorful pieces reflect Makoto Kawamoto's belief that a tray is more than a receptacle for food: just as a frame enhances a painting, a tray should frame the dish, harmonizing with the meal and making the dining setting more beautiful. To make his trays easier to use, Kawamoto designed them as thin as was practical.

Each of the four sides is a different width, so the layout of the trays adds visual rhythm to the table. He also colored each tray differently, to offset the colors of the food. The sides of the trays are first lacquered with *bengara* red earth pigment, then with a translucent amber. This technique allows the red of the bengara lacquer to appear delicately at the edges—a totally modern look that transcends tradition.

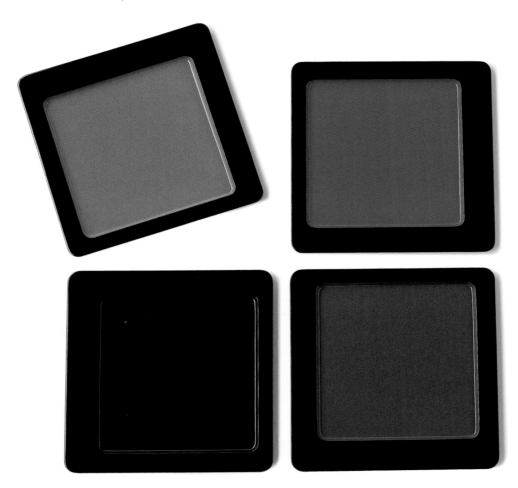

STACKED CUPS

Makoto Kawamoto

Kawamoto designed these cups to be stacked—not only to save space, but because when stacked they take on a new aspect that adds beauty to the shelf. Like other lacquerware from the northern district of Kawatsura, the cups were made using *hananuri*, a unique technique that applies, dries and finishes to such fine results that polishing is unnecessary. This method leaves smooth colors without blemishes or spots. And to make the colors stand out, the designer finished the indented stacking portion of each cup with a clear lacquer that emphasizes the grain of the wood.

Kawamoto believes the contrast gives the cups a sharp yet playful ambiance. Strong pigments are a convention of lacquerware, but Kawamoto's cheerful colors and their combination with the subdued woodgrain are original.

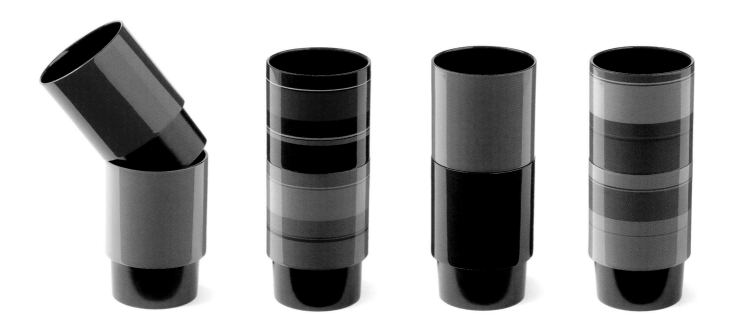

POP ART SAKE SET

Jun Takeda

Jun Takeda didn't want to use the traditional wood medium to make run-of-the-mill lacquerware; he wanted his pieces to celebrate pop art. So he used everyday PET (polyethylene terephthalate) bottles and soda cans to form these objets d'art, which can also be used as *tokkuri* sake servers and cups. The top of the server is part of a 500ml PET bottle and the bottom is from a 350ml soda can. The sake cups are made from small drink cans cut in half.

Takeda found it far more difficult making lacquerware from these materials than from wood, especially when confronted by the pull tab on top of the can. In the end, instead of lacquering a real pull tab, he carved the likeness of one into thick lacquer. His achievement is more than turning items that are ordinarily thrown away into lacquerware—the pains he takes to remain faithful to the originals reveals his dedication to craftsmanship. It is this, he believes, that keeps his work interesting.

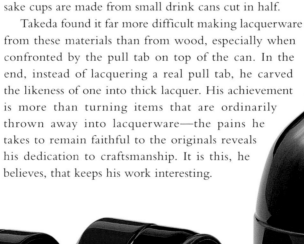

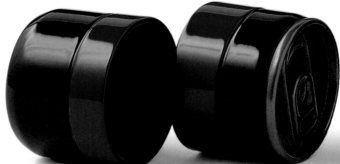

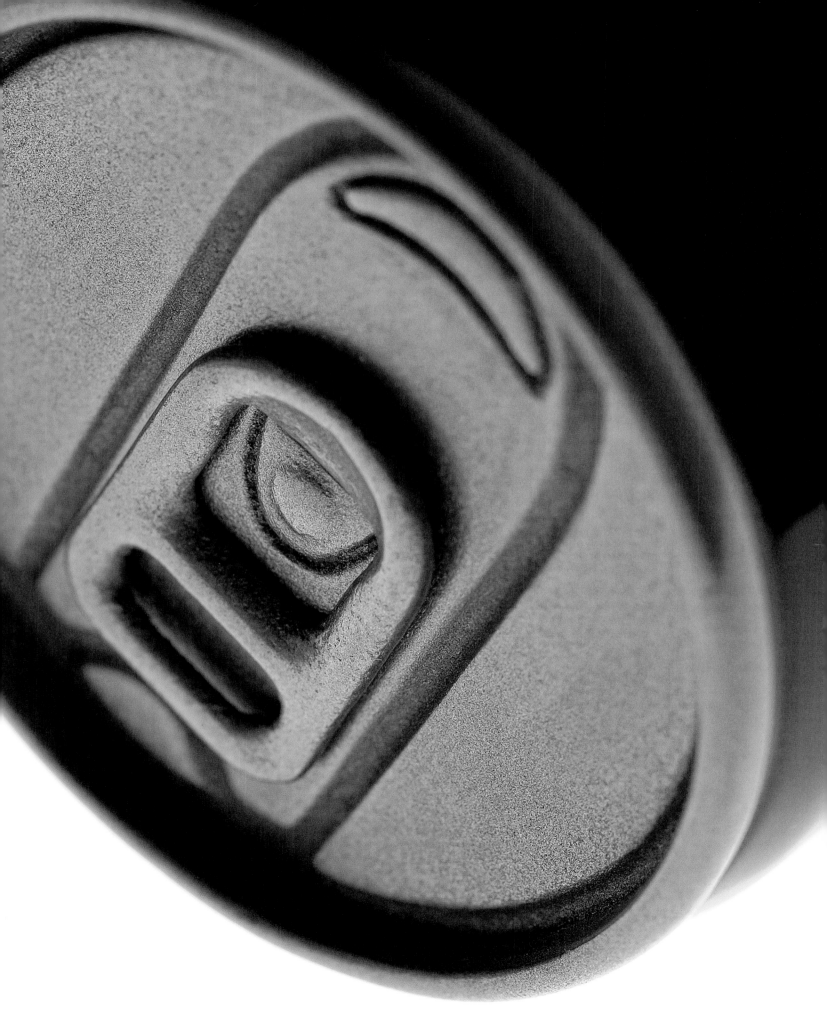

TEXTILES

Many Japanese rural homes were once equipped with working looms. Mothers and daughters were expected to spend their spare time weaving—most likely one of the four common fibers: hemp, ramie, cotton, or silk. Historically, however, common folk were forbidden to wear fine silk, and cotton was not cultivated until late in the Edo Period. So while nobles and samurai enjoyed silk, the garments of ordinary folk were of hemp, ramie, and later pongee—woven of floss from waste silkworm cocoons. These fabrics remain in use: Japanese regard hemp as cool to the touch, and in traditional homes when mothers change the *zabuton* cushions to ones of hemp, children know summer vacation is at hand. Pongee, meanwhile, has become one of the most treasured silks.

Japanese textiles are known for their distinctive designs and lavish colors, and a sophisticated dyeing industry has emerged over the centuries, with artisans developing a host of techniques. They dyed thread, for example, carefully calibrating the process so as the finished weave would bear a design, and dyed cloth by immersion or by painting. They refined resist techniques to selectively dye fabric—usually paste resist or shape resist, or tie-dying. They also developed natural dyes from plants such as indigo, safflower and turmeric. Indigo farming and dyeing was once so prevalent that Americans and Europeans referred to the color as Japan Blue—and Tokushima Prefecture is still renowned for its indigo.

Naturally dyed textiles and fabrics are said to be good for the health and environment, and while cloth may fade over time, it also grows more familiar and comfortable. While today's artists are too expressive to limit themselves to clothing, they remain pioneers—applying innovative dyeing and weaving techniques across their full field.

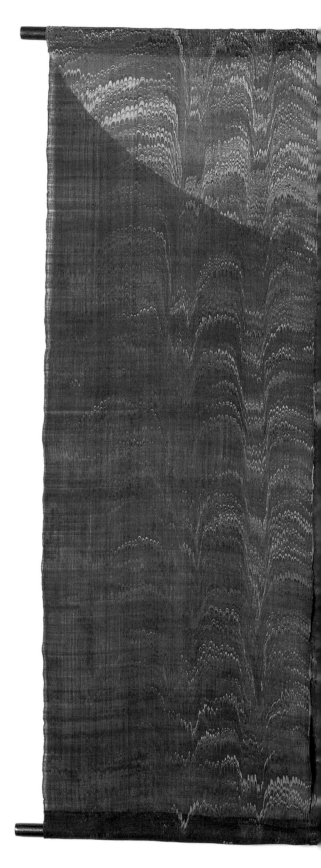

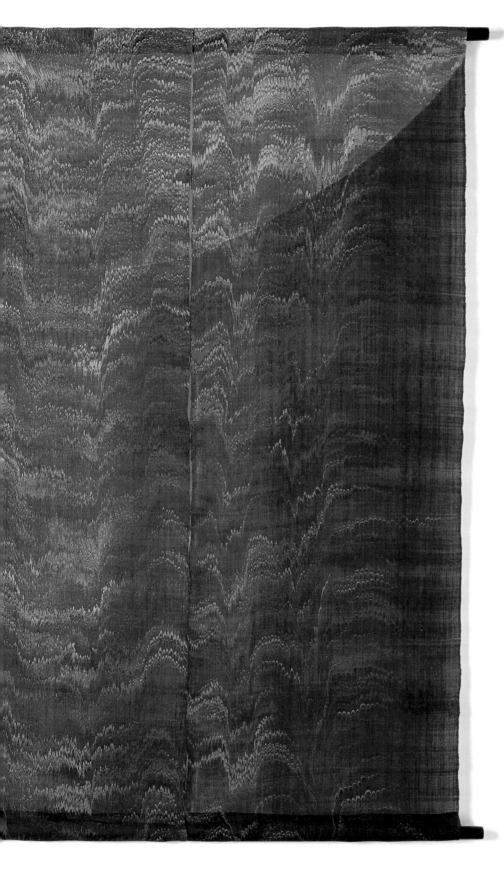

TAPESTRY
Minoru Ishihara

Minoru Ishihara experimented with many traditional dyeing methods before hitting upon marbling. No one is exactly sure of the technique's provenance: whether it is indigenous to Japan or came from China. It consists of spraying India ink and dyes on the surface of water, then transferring the resultant swirls onto fabric or paper. Ishihara finds the process and the effect express perfectly the images in his mind. The water, he says, is a catalyst, allowing him to commune with a faraway, primitive world from which he can feel the rhythm of the universe. The process itself, he believes, is an act of cleansing.

This work is three lengths of 60cm-wide cloth, arranged side by side and hung on a rod. Ishihara mottled lengths of linen with indigo, a plant dye, then applied white and five shades of blue in marbled motifs. The result can be used as a sunshade or room divider; he feels no need to sew the three panels together, because Japan's traditional *noren* curtains are divided as well.

TAPESTRY
Minoru Ishihara

Tawaraya Sotatsu and Ogata Korin, artists of the Momoyama and Edo periods, created the Rinpa school of brilliant color and decoration in arts and crafts. For this piece, Minoru Ishihara was determined to work in the spirit of Rinpa. Using the same techniques of the *yuzen* kimono artists, he selected a rice-based resist paste to create dynamic patterns and designs. After dyeing the basic pattern in black mixed with gold powder, he used white and black marbling to achieve his Rinpa-like effect. He chose a rough hempen textile so that the marbled dye takes in some places and not in others.

Ishihara strives to work with colors that no one else uses: the black of his background, for example, is made up of many colors, including one dye made from walnuts.

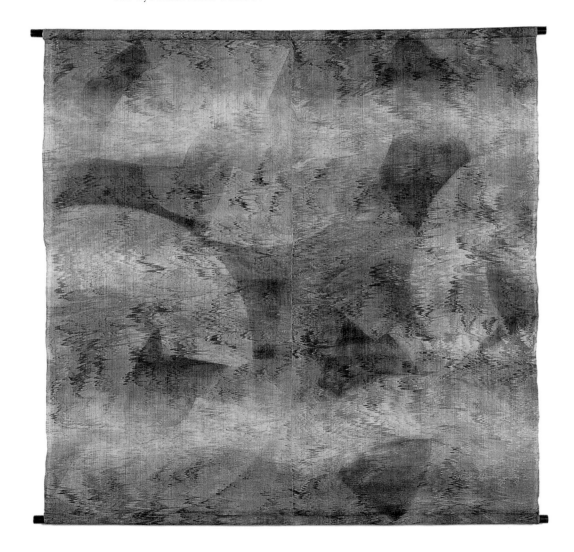

TAPESTRY
Sachiko Yatani

For this fascinating work, Sachiko Yatani took thread made from wild kudzu vines and dyed it with pigments made from chestnut husks, acorn cupules, and leaves of indigo plants. Then she wove it into warps of ramie, which is also called China grass. As the colors overlapped during weaving, Yatani imagined them as ice floes; she says she was reminded of how global warming is endangering the polar regions. When she finished weaving seven layers, she sewed "north pole" and "south pole" sections to the ends, giving life to her imagination.

To create her textiles, Yatani gathers and processes wild plants, an activity that gives her a grass-eye view of things. She says this perspective makes her aware of the damage caused to wild plants by today's consumption-mad lifestyle, a concern she believes is conveyed through her art.

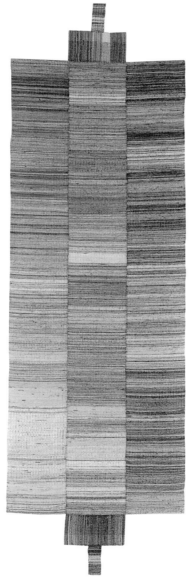

FUROSHIKI

Kaori Maki

In Japan, items for carrying or storing are traditionally wrapped in—not paper—but square pieces of cloth, usually of strong cotton or silk, called *furoshiki*. Since ancient times, people have developed ways of using furoshiki to creatively wrap all shapes and sizes. More than just practical squares of cloth, however, Kaori Maki sees them as interesting fashion accessories. She has created countless varieties, which she calls *tsutsumi nuno,* or "wrapping cloth," for display in exhibitions.

This work consists of two pieces of cloth layered together. The outer fabric is woven of hand-twisted silk thread from Japan, China, Cambodia, India, and six other countries, sometimes mixed with cotton or flax. The under layer of silk, visible through the weave of the outer fabric, is dyed in a color that makes the weave of the upper layer come alive.

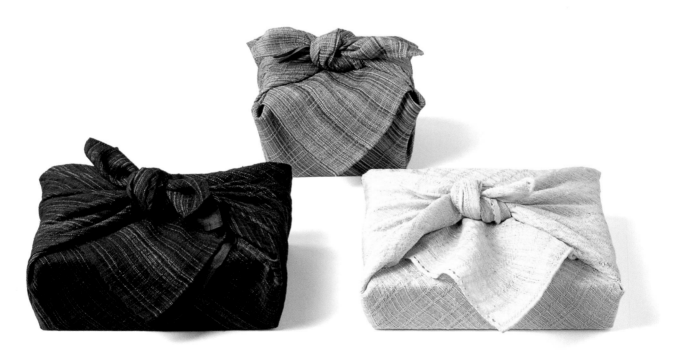

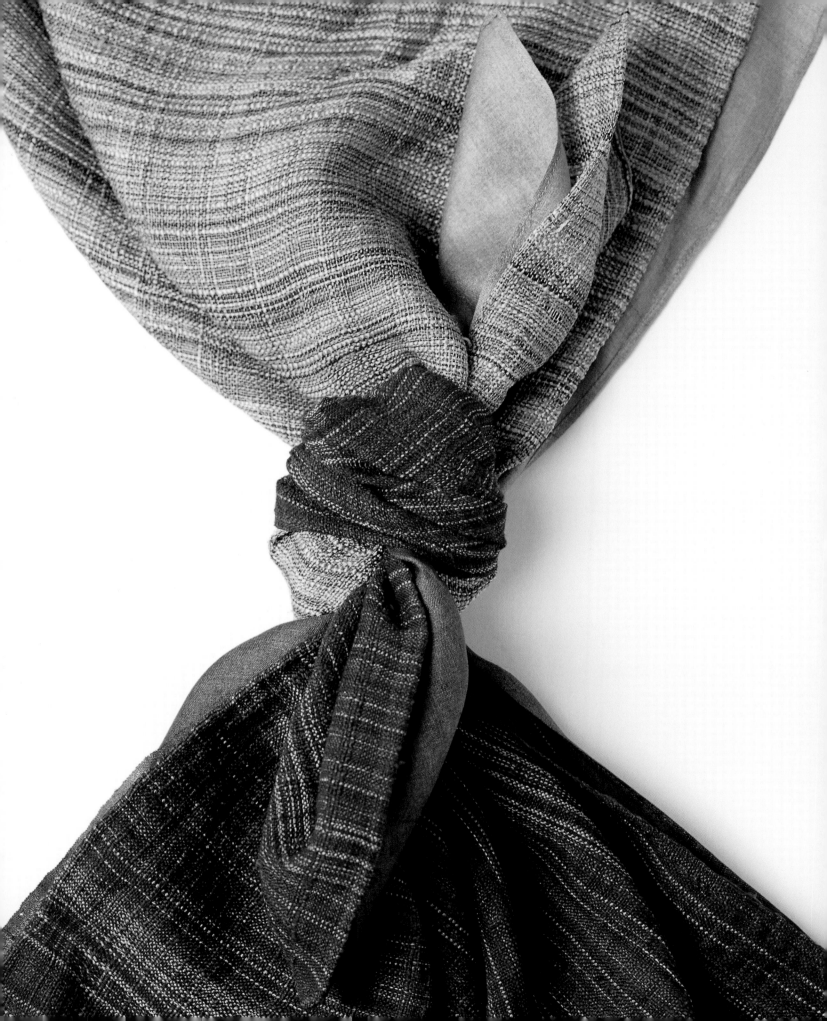

ZABUTON

Miho Usutani

With its *tatami* floor-dwelling culture, Japan could not do without zabuton cushions. The cushions are extremely simple: nothing more than a length of cloth folded in half, with cotton batting placed between the halves, the three sides stitched up, and another stitch taken in the center to keep the batting from shifting. As lifestyles changed, though, and tatami were replaced with carpets and other Western flooring, chairs and sofas began to take the place of the once ubiquitous zabuton. Still, if there's even one tatami room in a home, the cushions are a must.

Miho Usutani flouts the traditional sizes and shapes and creates zabuton that are very much modeled on her own vision. She puts stitches in the fabric before dying with indigo, so that distinctive patterns are formed on their removal. She often uses white lines for a light and original look that give her zabuton the appearance of personal scratch pads.

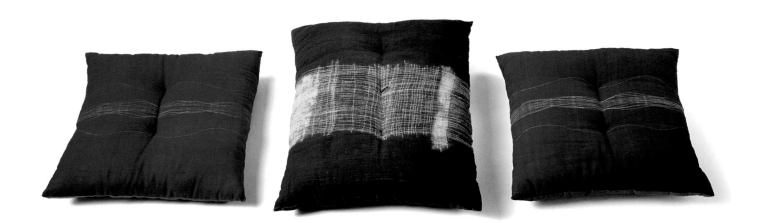

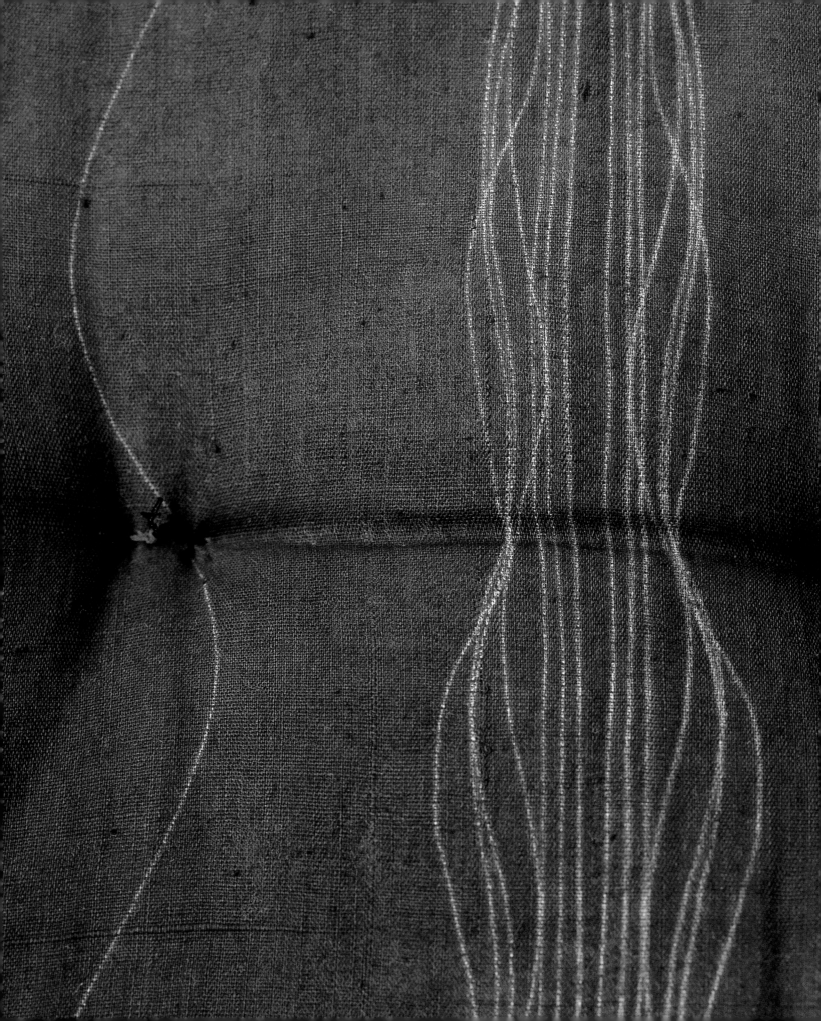

TAPESTRY
Masako Moryo

Masako Moryo doesn't want hanging fabrics to slice her space in half; instead, they should have spaces and slits that make them seem to be there yet not there. Simply put, a piece should melt into a space rather than divide it. To bring her concept to life, Moryo took a hint from traditional silk crepe, which is woven with a great deal of twist in the woof to create wrinkles.

For this tapestry, she chose a hard, thick thread with lots of twist and wove it in a flat, basic method. The finished tapestry coils, twists, and tangles with a lightweight presence that allows air and light through freely. The rich, dark brown coloring comes from fig, sorrel, and willow dyes.

STAINLESS STEEL CLOTH

Nobue Saito

Nobue Saito is intrigued by fleeting, ephemeral phenomena like air, which is invisible; or glass, which is transparent; or the traditional textiles of silken gossamer or gauze, that are translucent and create a shimmering moiré when layered. She conducted test after test trying to produce a concrete example of the fugitive images in her mind. Finally, by twisting mohair fibers onto stainless steel wire as a thread for weaving, she created a wavy, intriguing fabric that came very close to her idea of vapor in the air.

Saito gave her work shape and form by folding and straightening the fabric, then crushing it and spreading it out. She wove it as a tapestry, but believes it might be fun to wear around the neck, perhaps as a unique type of stole.

WOOD

Native timber is historically Japan's construction material of choice, for either the humble abode or the structure built to inspire awe. Still standing in Nara are the world's oldest wooden building—the main hall at Horyuji Temple, finished at the beginning of the eighth century—and the world's largest, rebuilt in 1709 at Todaiji to house the Great Buddha.

Forests cover seventy percent of Japan's mountainous archipelago, and the varied climate, from the subarctic north to the subtropical south, provides rich resources, ranging from softwoods such as cedar and pine, to hardwoods like beech, oak, and zelkova.

Of course, Japanese wood-use goes far beyond that of building. Craftsmen take pains to bring out the beauty of the grain, and their joinery exhibits precision tongue-and-groove techniques—in furniture, decorative items, or everyday containers. In the small wooden vessels that form the bases for lacquerware, for instance, joints must expand and contract without cracking the coating, a skill that takes decades to hone.

Round items require different skills, and over the years wood turners, coopers, and bentwood craftsmen have refined their production of household utensils. Traditionally, turners made soup bowls, round trays, and other utensils (until the Edo era most commoners ate from wooden bowls and trays). Everyday life also demanded containers such as buckets, tubs, and bathtubs. These were made by coopers, who fitted cedar or cypress staves to round wooden bases, then bound them with metal or bamboo. Another common round container was made of bentwood—craftsmen split off and soaked thin veneers of cedar or cypress, bent them around a form, tied them with bark, then fastened on a bottom to make *bento* lunch boxes or *seiro* steamer baskets.

Carvers and other artists are acutely conscious of wood's value, and treat this natural treasure with the greatest respect. One of the factors behind their superb skills is the availability of superior blades, and despite modernization, the use of high quality hand-tools has helped sustain the Japanese woodworker's traditional concern for excellence.

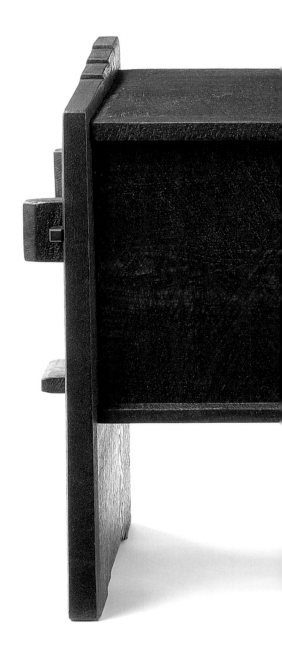

NOMADIC CHEST
Ryohei Kido

Before the advent of buzz-saws, traditional *kobiki* sawyers used huge frame-saws called *oga* to rip timber into boards. The marks left by the oga in century-old boards attracted Ryohei Kido, and became one of two inspirations for this chest. The other was when he discovered pictures of Western Asian nomads crossing the desert, their furniture loaded on camels. They carried collapsible chests with geometric designs, made to be held together with wedges. From the pictures, Kido imagined a chest with the toothmarks of an oga displayed to full advantage.

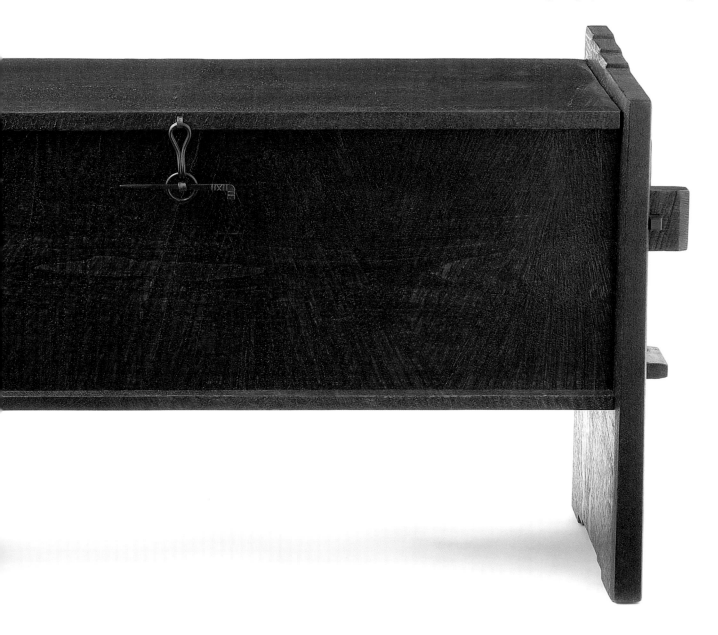

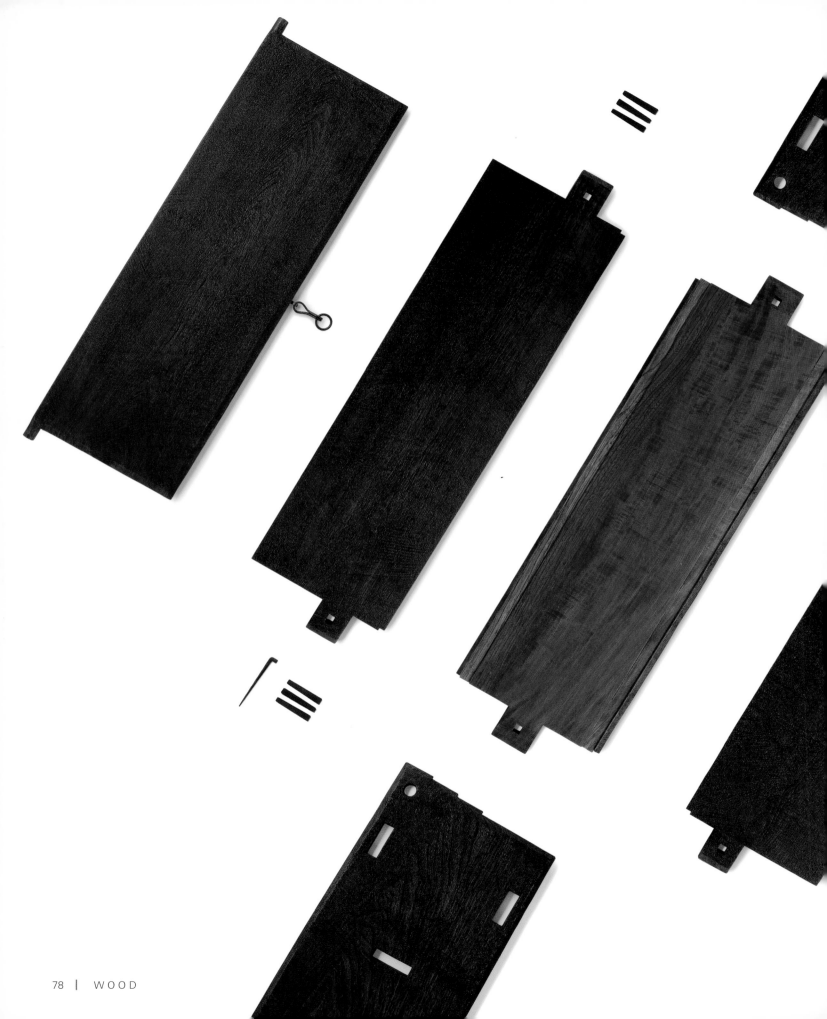

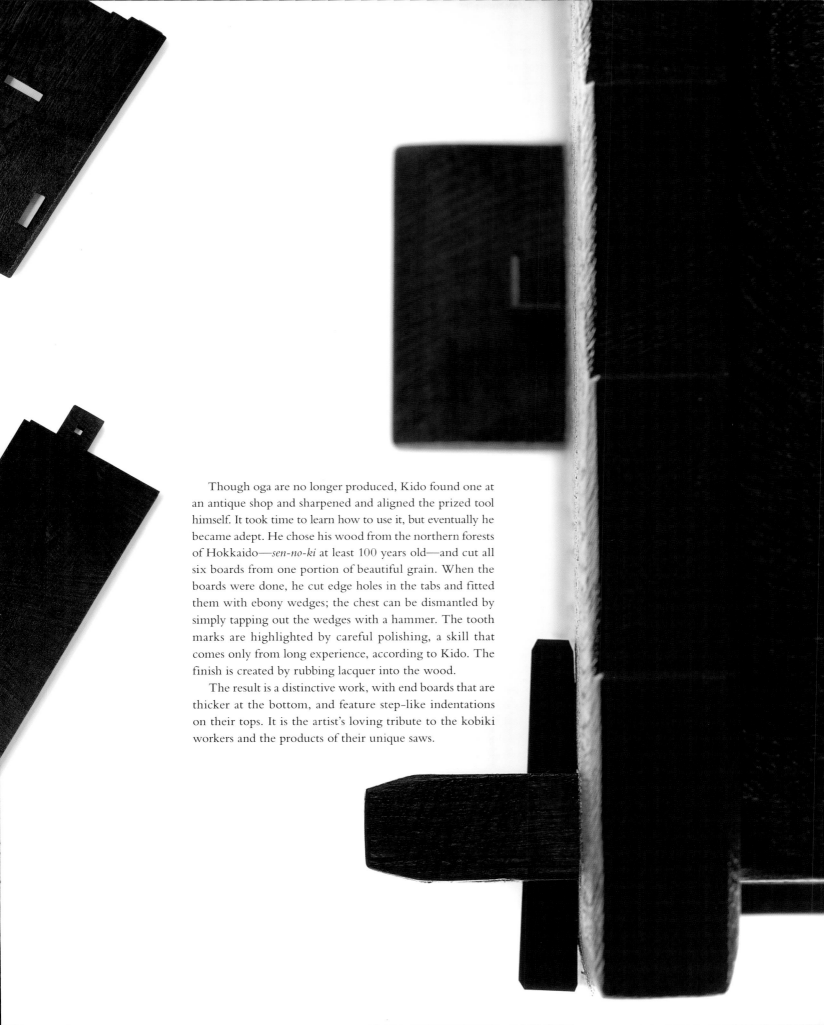

Though oga are no longer produced, Kido found one at an antique shop and sharpened and aligned the prized tool himself. It took time to learn how to use it, but eventually he became adept. He chose his wood from the northern forests of Hokkaido—*sen-no-ki* at least 100 years old—and cut all six boards from one portion of beautiful grain. When the boards were done, he cut edge holes in the tabs and fitted them with ebony wedges; the chest can be dismantled by simply tapping out the wedges with a hammer. The tooth marks are highlighted by careful polishing, a skill that comes only from long experience, according to Kido. The finish is created by rubbing lacquer into the wood.

The result is a distinctive work, with end boards that are thicker at the bottom, and feature step-like indentations on their tops. It is the artist's loving tribute to the kobiki workers and the products of their unique saws.

FOLDING DESK

Yoshifumi Nakamura

Unraveling the name of this folding desk requires a bilingual capability and cultural knowledge. Architect Yoshifumi Nakamura took his inspiration from the desks in the meditation hall at the renowned Todaiji temple in Nara. The hall is called Nigatsudo, or "February" Hall—thus the title "FEB." for this modern version of those traditional temple items.

Nakamura designed the desk for study or eating when unfolded, and as a platform for ikebana flower arrangements or objets d'art when folded. For the surface of the desk and the drawer, he used *kiri* (paulownia) wood for its lightness, and for the legs—where strength is required—he used walnut. Worth noting are the walnut dowels at the four corners, which act as wedges when the desk is unfolded, holding the legs in their vertical position. The result is an architectural achievement: beautiful, simple and entirely functional.

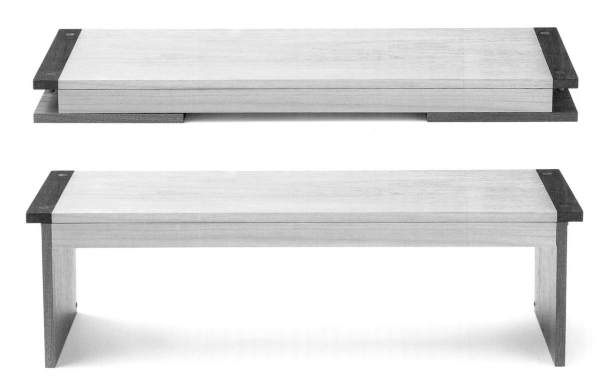

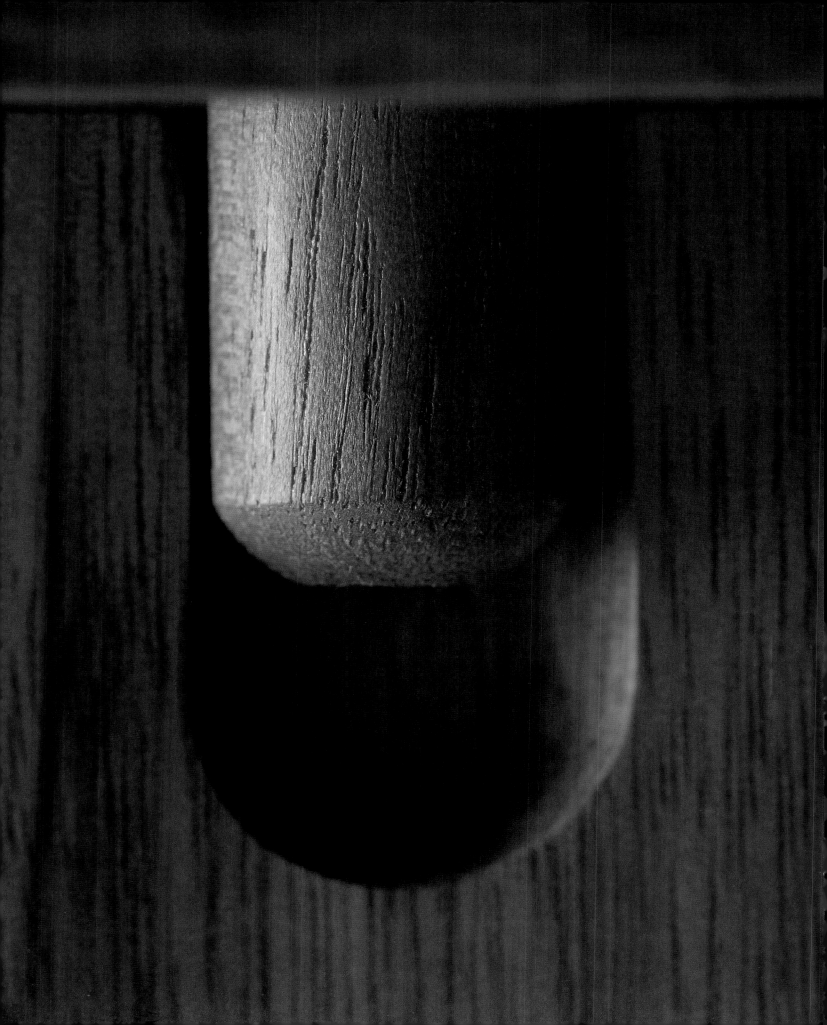

L-SHAPED PLATES

Ryuji Mitani

A dish or a plate should be more than a vessel to hold food, believes Ryuji Mitani. Even such an ordinary item should always have something extraordinary about it.

Take these L-shaped plates. They might be an abstract sculpture to hang on the wall. Or, you could place one in a V to serve snacks between friends, sitting with drinks at a corner counter. Two plates together form a perfect square; more can be combined—like children's blocks—into various shapes and forms. Their use is only limited by the imagination. The plates are made of cherry wood, blackened with vegetable dye in a unique method that emphasizes the chisel marks in their surfaces.

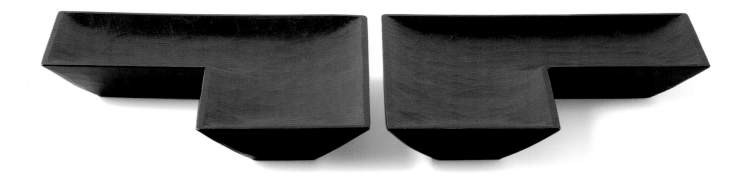

PORTABLE SEATS

Taiichi Kirimoto

Ho-kijishi are the woodcarving craftsmen (on the venerated level of cabinetmakers in the West) who make the high quality wooden bases that eventually become the highly valued *Wajima* lacquerware of Ishikawa Prefecture. Taiichi Kirimoto is a third generation of carvers who specialize in making the decorative cabinet legs and other ornaments. After a career as a product designer for a Tokyo firm, he returned home to take over his family atelier. He says that the "Kiri" of his name gives him a special empathy for the paulownia wood—an illustrious connection, since the Japanese have a closer affinity to kiri than any other wood. Chests made of kiri were traditionally used for storing kimono, because the wood insulates against heat and wards off harmful insects; in fact, anything valuable was kept in a *kiri tansu* chest.

Kirimoto makes products that show off the wood's merits, hoping to revitalize people's appreciation of it—and these portable seats are a fine example. The removable bases are assembled in a cross and inserted into the round seat, whose smooth curves are finely turned by Wajima craftsmen. The sensation of sitting on the soft, delicate wood, whether cross-legged or in the traditional kneeling position, is akin to floating on air.

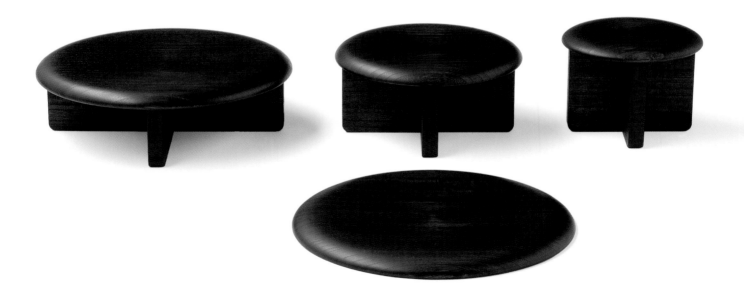

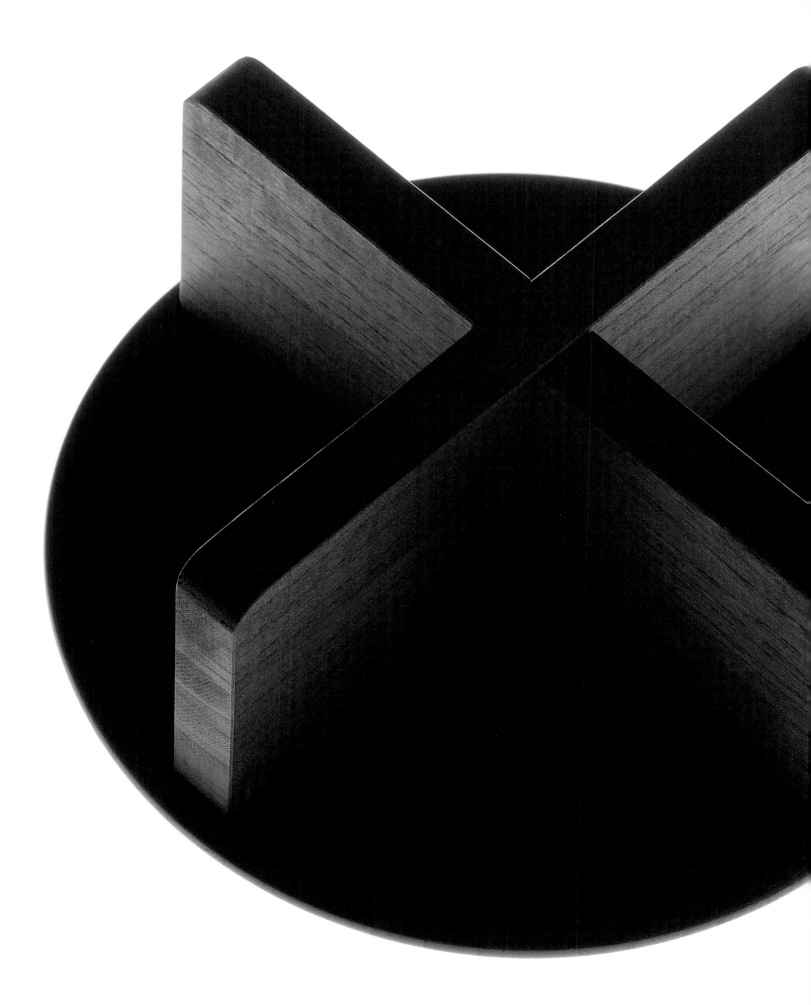

OAK CHAIR

Toshihiko Yanagihara

Chairs with four legs easily damage delicate tatami floors, but rarely is this clever idea seen: rails running between the legs to spread the weight and help protect the straw matting. In fact, the tatami-protecting rails of this chair do much to enhance the beauty of Toshihiko Yanagihara's design. The piece is made of *nara* oak, which the artist saw in the grammar school building of his youth and never forgot. With this dense hardwood, the mortise and tenon joints remain tight, and Yanagihara can create chairs with minimum waste and the simplest possible construction—more reasons why he chose the oak. He is intrigued by traditional Japanese temples and shrines such as the Grand Shrine at Ise; modern furniture from overseas; and the Shaker furniture of the United States. This chair distills all these influences.

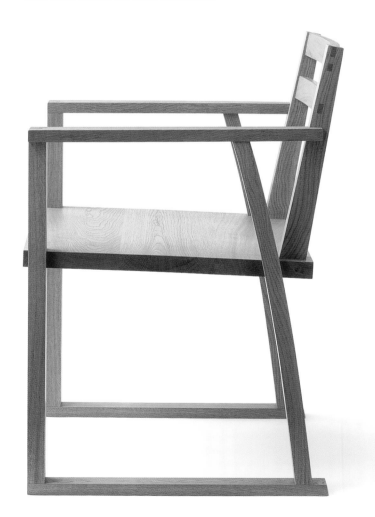

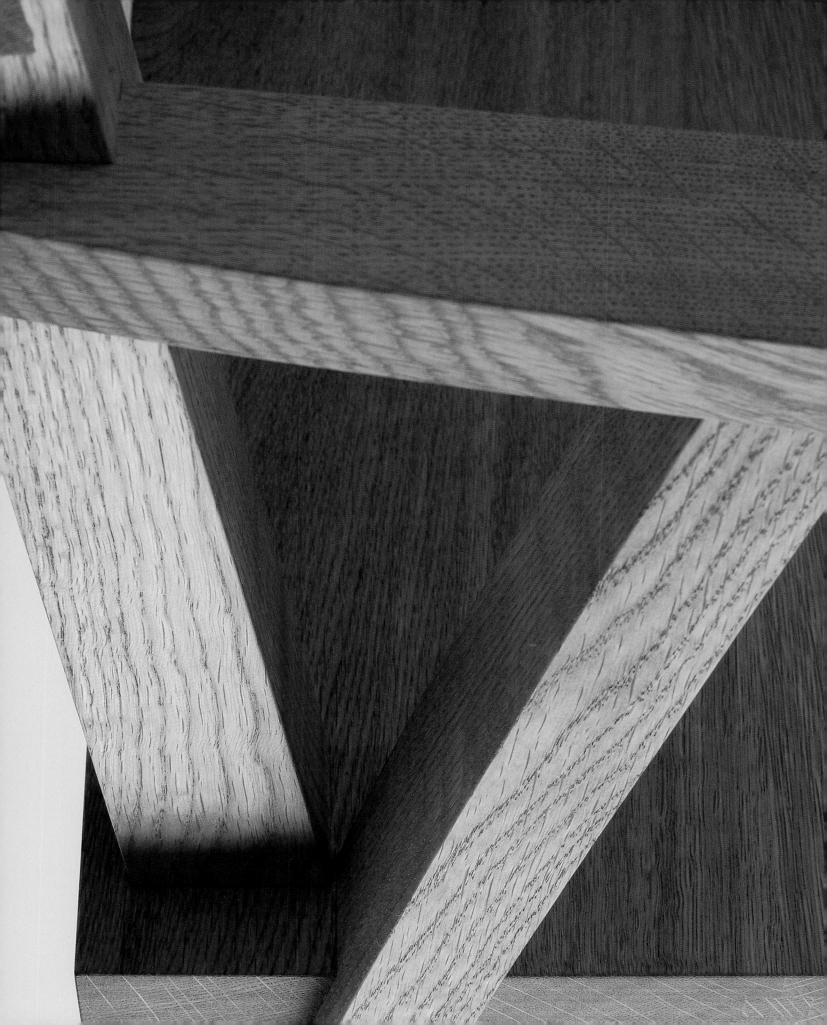

BENCH
Shinji Hongo

While a student, Shinji Hongo often visited the historical temples and shrines of Nara and Kyoto, and came to appreciate the breathtaking pillars and beams in those remarkable wooden structures. Since then, he has used wood from old buildings to create furniture and abstract artworks, finding a spirit of renewal in this pursuit. Whether the wood is from an Edo-period *minka* house or a relatively modern apartment building, it is all fodder for Hongo's creativity. To him, the mortises and the cracks in the timbers are merely part of the whole, and help determine the shape of the creation.

This bench seat is from a piece of *keyaki* zelkova hardwood, the legs are from pillars of pine, and the L-shaped reinforcement is kiri. The work is an amalgamation of whatever material was available and that, in Hongo's vision, fit together. To color the chair he used India ink mixed with vegetable oil, bringing the different timbers into a harmonious yet contrasting whole.

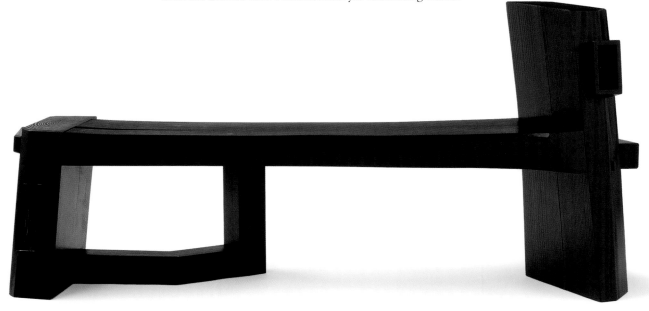

KATAKUCHI

Mitomu Yamamoto

Katakuchi are small pitchers with a spout but no handle. In the age before the modern measuring cup, they were also used as measures. Each was made to hold a fixed amount—there were no marks on the body—so if a customer ordered one-*go* (180ml) of sake or shoyu at a local shop, he was served by the proprietor using a one-go katakuchi.

Today, making katakuchi is popular among hobbyists, who create the containers out of lacquerware, pottery, glassware or other materials. The use of the pitchers has stretched beyond sake and such to serving vessels and ikebana flower arrangement holders. The makers of lacquerware katakuchi tend to make the spout separately from the body, connecting the two just before the lacquering process. Mitomu Yamamoto, however, makes his from a single piece of wood, letting the grain dictate the position and shape of the spout, sometimes unaware of the final shape when his work begins. He is especially intrigued by roots and knots that result in unique shapes. In the final step of the process, he rubs thin lacquer into the wood and then sprays the entire piece with lacquer so the grain stands out clearly.

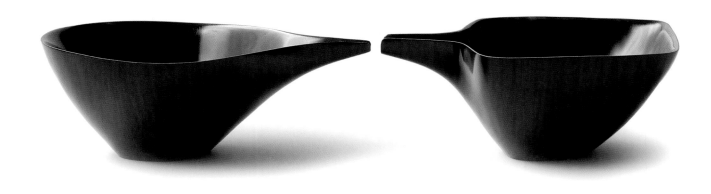

AKEBIA VINE

Since ancient days, craftsmen have used akebia vines and wisteria runners to weave containers for storing and carrying household items. Farming families used the off-season to make similar items for their own use.

Akebia grows wild throughout Japan. In warm climates the stems are whitish; in colder regions they acquire a beautiful reddish hue. Harvested in December after the leaves have fallen, the vines are placed in the shade to dry, then soaked until pliable before weaving.

Few rural families make their own baskets today. But akebia weaving is enjoying a revival among artists inspired by its natural flexibility and strength.

BASKET
Masako Maki

In her work, Masako Maki seeks both the artistic and the practical, but doesn't make the choice herself. This akebia vine basket resembles a sphere that has been depressed in the middle. It can be looked upon as an object by itself, or perhaps used as a basket for ripe fruit. She weaves the vine without a break, but not tightly, so light and air can find their way through and around the work. The method she uses is called *midare ami*, or random weave, and originated with bamboo baskets. She runs the vines around a crumpled newspaper core until the weave is even and the entire sphere is covered. The core is then removed and the artist indents the center to achieve this shape.

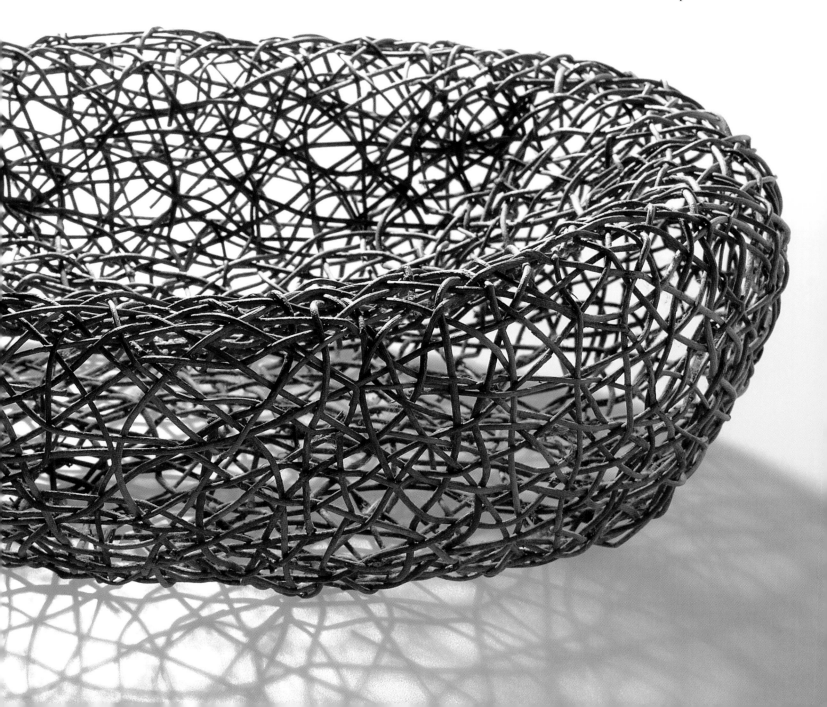

CLAY

Japanese ceramics can boast a global artistic reach: more students come to Japan to learn ceramics techniques and aesthetics than to study all the other traditional crafts combined.

The beginnings of Japanese unglazed earthenware can be traced to the prehistoric Jomon Period; its unglazed stoneware to *anagama* tunnel kiln technology from Korea; and its glazed pottery and porcelain to Chinese influence and Korean potters.

But the main impetus to the birth of a Japanese aesthetic came with Zen Buddhism, which arrived in the twelfth century and blossomed with the introduction of *zazen* meditation by Dogen Zenji (1200–1253). The meeting of Zen and the inherent soulfulness of earthenware inspired a ceramic art which eschews artificial form and strives for spirituality. Examples are the works for use in the tea ceremony, which had profound influence on pottery.

The tea masters preferred unglazed stoneware, such as the products of the Shigaraki and Bizen kilns, because the use of such vessels gave the ceremonies a fresh, unaffected air. The simple works also affected the decoration of tea rooms, and through this they influenced daily life. It is no exaggeration to say common ceramic tableware developed from the tea ceremony, and in works being made today, the spirituality of Japanese ceramics is clearly alive.

SPHERICAL BOWLS
Seijiro Tsukamoto

Thrown on a potter's wheel, sphere-like ceramic shapes acquire walls of consistent thickness, so there is little warping during firing. But if the potter creates similar shapes on a mold, it is virtually impossible to produce walls of uniform thickness, because the pressure of fingers on clay naturally varies. The spheres have a tendency to warp when they're fired—and that's fine with Seijiro Tsukamoto. The slightly skewed forms that emerge from his kiln are the ideal he seeks—inspired, in fact, by the clay pots of Africa. He prefers unglazed pieces but sometimes glazes the inside to make his vessels easier to wash. The juxtaposition of interior and exterior colors, and the plain fired surfaces, achieves a striking beauty.

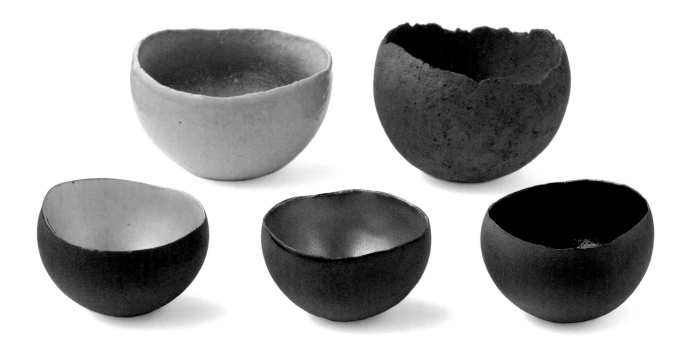

PAPER MULBERRY

Paper mulberry is a small tree that farms easily and bears annual fruit. Historically it has been grown all over Japan for its bark—used in the same way as hemp, ramie, and kudzu arrowroot, its string-like fibers are woven into fabric. Farmers also wove baskets from its bark.

Today most of Japan's bark goes into washi paper, and the tree is raised in the Tosa region of Kochi Prefecture, a hub of washi making. The fibers are taken from the inner bark, which is separated from the outer bark after the wood is cut and steamed. In the hands of contemporary artists, mulberry's distinctive qualities result in finished works quite different from similar ones made of akebia or bamboo.

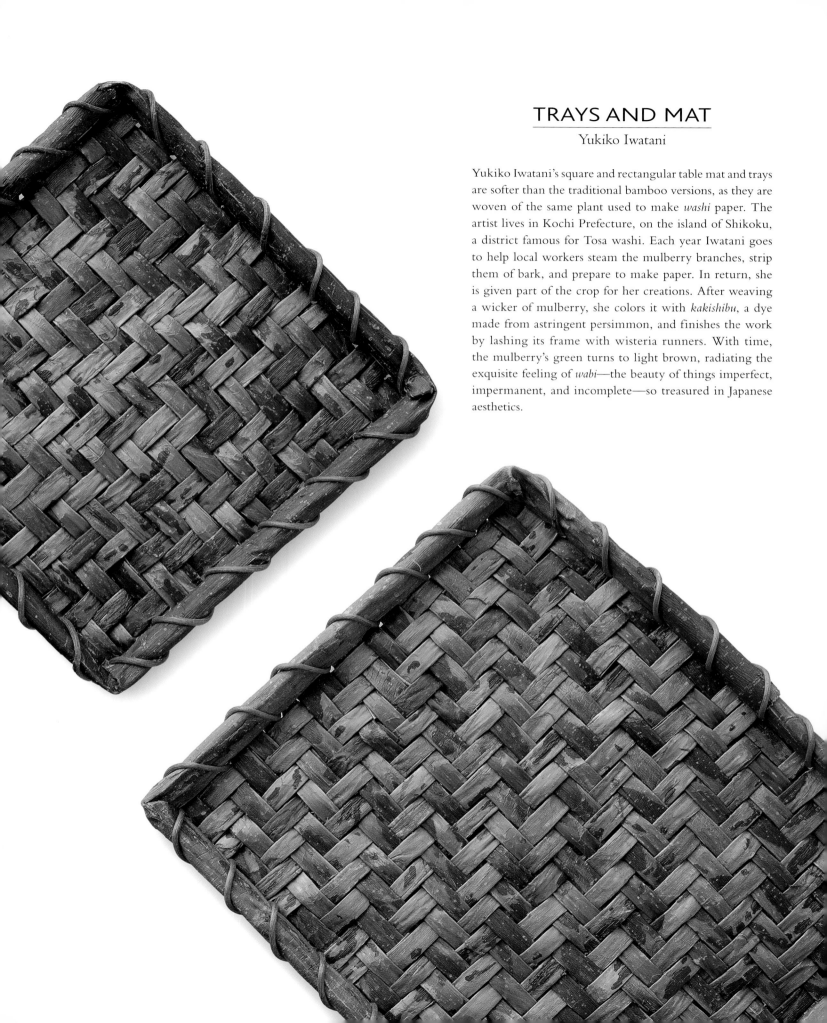

TRAYS AND MAT
Yukiko Iwatani

Yukiko Iwatani's square and rectangular table mat and trays are softer than the traditional bamboo versions, as they are woven of the same plant used to make *washi* paper. The artist lives in Kochi Prefecture, on the island of Shikoku, a district famous for Tosa washi. Each year Iwatani goes to help local workers steam the mulberry branches, strip them of bark, and prepare to make paper. In return, she is given part of the crop for her creations. After weaving a wicker of mulberry, she colors it with *kakishibu*, a dye made from astringent persimmon, and finishes the work by lashing its frame with wisteria runners. With time, the mulberry's green turns to light brown, radiating the exquisite feeling of *wabi*—the beauty of things imperfect, impermanent, and incomplete—so treasured in Japanese aesthetics.

RICE STRAW

Rice straw became a part of Japanese life with the arrival of wet rice cultivation in the Yayoi Period. The straw saw numerous uses: as rope, mats, outer wear to ward off cold, footwear, bags, and containers to keep food warm. It was also credited with mystical properties, and used in the production of religious effigies for special prayers and to ward off evil, and as sacred ropes to delineate boundaries. It was even used to make toys, brushes, and a type of washi paper.

Traditional rice-straw items such as sandals have virtually disappeared, but shrines still use straw ropes on festival days such as New Year holidays, when the ropes also decorate homes.

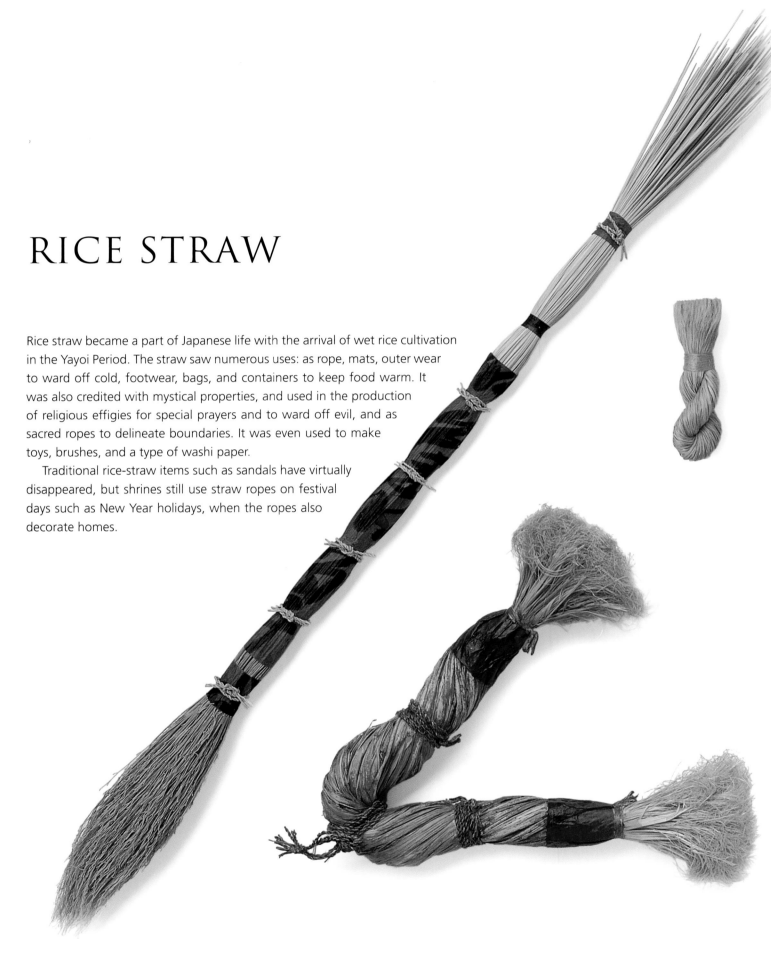

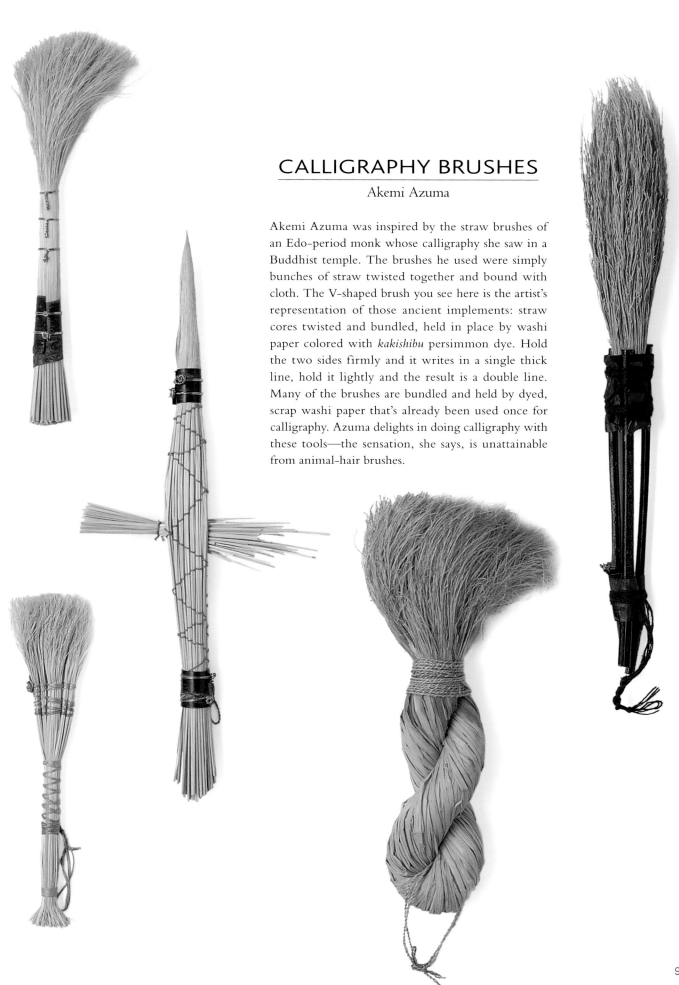

CALLIGRAPHY BRUSHES

Akemi Azuma

Akemi Azuma was inspired by the straw brushes of an Edo-period monk whose calligraphy she saw in a Buddhist temple. The brushes he used were simply bunches of straw twisted together and bound with cloth. The V-shaped brush you see here is the artist's representation of those ancient implements: straw cores twisted and bundled, held in place by washi paper colored with *kakishibu* persimmon dye. Hold the two sides firmly and it writes in a single thick line, hold it lightly and the result is a double line. Many of the brushes are bundled and held by dyed, scrap washi paper that's already been used once for calligraphy. Azuma delights in doing calligraphy with these tools—the sensation, she says, is unattainable from animal-hair brushes.

STONE

With its links to religion, stonemasonry has a long history in Japan, and remains vigorous today. Rich veins of high-grade granite near Kyoto provided impetus to the industry, whose artisans carved temple and shrine foundations, gravestones, pagodas, spiritual statuary, and lanterns.

The modern stonemason focuses chiefly on gravestones, but craftsmen produce lanterns, steps, gates, bridges, basins, and small pagodas and shrines. Japanese seem to have a special feeling for stone—worked or natural—and uncut stone, especially, strikes a chord.

Inkstones, too, are part of ancient heritage. Grinding ink involves rubbing an inkstick, together with a little water, on a stone. For best results, the inkstone's "teeth"—the grain of the stone—must be uniform: hard and well-balanced. The stone must also be chemically inert, able to last for centuries, and as impermeable as possible, so as to absorb only the tiniest amount of ink. Most important, the stone's pattern must be beautiful. Most inkstones are made of slate by veteran craftsmen—hollowed, polished, and finished with wax and lacquer. Today, inkstone craftsmen make various implements for everyday use, extending their skills in new directions.

INKSTONE PLATES
Ryoichi Kobayashi

Ink for Japanese calligraphy and *sumie* ink painting is made by rubbing an inkstick in water on an inkstone—usually made of hard black slate. One kind of slate that is often used is *ogatsu ishi*, found in Miyagi Prefecture. Kobayashi was intrigued with the way slate splits almost perfectly horizontally, and by its soft texture. Ogatsu ishi slate doesn't even look like stone, which is why the artist selected it specifically for these plates. In fact, after finishing this project, he developed an interest in inkstones and has begun designing them.

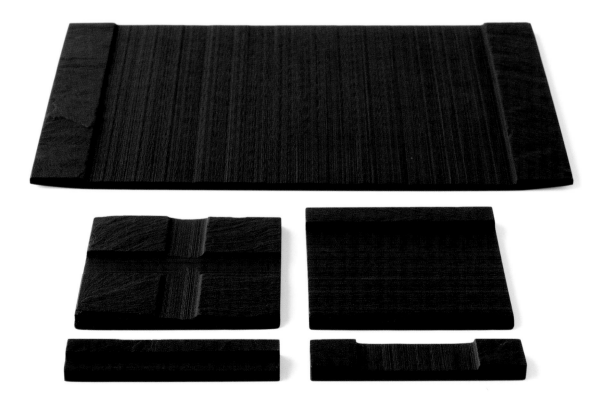

GLASS

Glassworking probably came to Japan from abroad: archeologists believe beads unearthed from Yayoi-period digs were made using methods gathered along the Silk Road, or brought on trading ships. Temple records from the Nara Period refer to "casting, coiling, and blowing" as techniques for glass bead making, and craftsmen also produced glass Buddhist statues and altar ornaments. But with the Muromachi-period spread of Zen Buddhism—which frowned on image worship—glass production declined and almost died out. No glass was made for many years.

Thanks to foreign influence, the Edo period saw blown glass, called *vidro* from the Portuguese, begin to be produced in earnest, along with Edo cut glass, which was termed *goudsmid*—Dutch for "diamond." Edo cut glass also spread to Saga and Satsuma, while Chinese techniques engendered the thin blue glass of Nagasaki.

In the late nineteenth century, Japan absorbed modern glass technology from the United Kingdom and Germany, and foundries began using soda lime glass to make inexpensive lamp chimneys, oil pots, and liquor bottles. Mirrors and flat window glass were produced for the first time. Today, of course, most glass is made in highly mechanized factories, but traditional glass foundries run by inspired craftsmen survive.

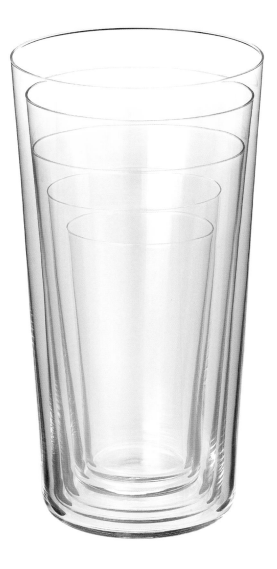

DRINKING GLASS SET
Shotoku Glass

These incredibly delicate-looking yet surprisingly sturdy pieces were born from light bulb-making techniques developed by the Shotoku glass foundry in the early twentieth century. The glasses were conceived when the foundry owner and his workers were out on the town one night—so they are surely ideal for sharing some drinks and conversation. The extra-large LL size holds one 350 ml can of beer, which, chilled to 6 degrees Celsius and poured, achieves the perfect balance of 70 percent beer and 30 percent foam in the glass. The mid-size M glass allows two people to share a 350 ml can of beer, with the same perfect balance. And the small S size, found only in Japan, holds just enough beer for one or two swallows. The Shotoku philosophy is to apply traditional skills to making products that fit today's lifestyles, and these glasses are one impeccable result.

THE ARTISTS

Pages 2–3
KATAKUCHI
W13.5×D8.5×H8.2cm (W5$\frac{1}{3}$×D3$\frac{1}{3}$×H3$\frac{1}{4}$in.)

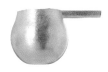

Pages 28–29
SILVER-PLATED VESSELS

From Left:
"Tripod Katakuchi" W18.5×D10.5×H9.5cm (W7$\frac{1}{4}$× 4$\frac{1}{8}$×3$\frac{3}{4}$in.)
"Tripod Goblet" W8.5×H6cm (W3$\frac{1}{3}$×H2$\frac{1}{3}$in.)
"Tripod Carafe" W11.2×D11.5×H19cm (W4$\frac{3}{8}$× 4$\frac{1}{2}$×7$\frac{1}{2}$in.)

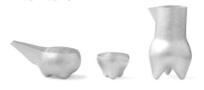

MIZUKO YAMADA

Mizuko Yamada was born in 1964 in Tokyo, where she grew up in an artistic environment—her father is a sculptor and her mother a jeweller. After studying metal work in the Crafts Department at Tokyo National University of Fine Arts and Music, she continued with silversmithing in graduate school. She chose metal work because the artist gets to control every step of the process, unlike ceramics, for example, where the work cannot be controlled while it is in the kiln.

In 1995, Yamada became an artist in residence at the Royal College of Art in London. This reawakened her interest in traditional sculpture and perfecting Japanese techniques, but refusing to be limited by the bounds of tradition, she began work on her tripod series, working first on goblets.

After a brief stint back in Tokyo, in 1997 she went to the Edinburgh College of Art in Scotland, where she was artist in residence for one year. After her return, she taught at the junior college and college levels while working in her atelier in Tokyo's Shibuya district. Yamada creates three kinds of works: large objects of art, vessels such as sake servers and flower vases, and jewelry, but she considers jewelry objects of art that people can wear. Beginning in 2003, she began to rediscover the beauty of Joseon Dynasty porcelain and began a new phase of her career—reproducing the beautiful curves of Joseon porcelain ware in metal. Her exhibitions include:

1995 Modern Japanese Jewelry Exhibition, Museum of Decorative Arts, Ghent, Belgium
1998 Individual exhibition, Andrew Grant Gallery, Edinburgh, Scotland, UK
1999 Contemporary Decorative Arts, Sotheby's of London, UK
2000–04 Mikromegas, Munich, New York, Geneva, other major international cities
2001 Contemporary Japanese Jewelry, Crafts Council, London, UK

Contact: Mizuko Yamada
E-mail: mizuko@attglobal.net

Pages 10–11
SUSUTAKE BED L252×W70–90×H69cm
(L99×W27$\frac{1}{2}$–35$\frac{1}{2}$×H27in.)

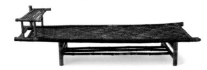

Pages 12–13
KNIVES AND FORKS 16cm (6in.)

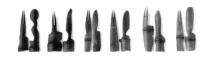

NAOTOMO INAGAKI

Naotomo Inagaki was born in Tokyo in 1942, and has enjoyed working with his hands since childhood. From his mid twenties, he lived for ten years on one of Kagoshima Prefecture's Tokara islands, where he learned to live off the land. He thought he could earn money working with materials at hand, and—intrigued by the beauty of woven bamboo—he began learning how to weave bamboo baskets. He apprenticed himself to bamboo basket weaver in Kumamoto Prefecture.

Inagaki moved to Kasama in Ibaragi Prefecture in 1978, where he set up his own workshop. Later, he moved again to Kamogawa, Chiba Prefecture. There he noticed the beautiful patterns of susutake smoked bamboo, and began making furniture and small objects from the material.

When homes built in the Edo period get torn down, Inagaki hurries to help with the process, particularly rescuing the susutake supports from the thatched roofs. At one time, he'd been able to gather enough material to last the rest of his life, but while he was away one day, his house caught fire from the wood furnace that heated the bath, and his entire collection of the material was destroyed.

"Thankfully, everything I exhibited has been sold—and I know who owns them," says a resigned Inagaki. "I can go see them any time I wish." He now lives in a house he rebuilt himself, writes most of the time, and makes works from bamboo or salvaged lumber, only when it pleases him to do so.

Contact: Sunada
For bed: 0436-21-5818 (fax)
For Knives and Forks: Zakka
E-mail: zakka-h@mx5.ttcn.ne.jp

Pages 14–15
SCREEN LIGHT
W75×H120cm
(W29$\frac{1}{2}$×H47$\frac{1}{4}$in.)

Pages 16–17
LIGHT STAND
H120cm (47$\frac{1}{4}$in.)

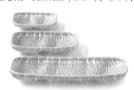

TOSHIKO KAWAGUCHI

Toshiko Kawaguchi was born in Kamo, Niigata Prefecture, in 1956. Kamo is renowned for *kiri tansu*, chests of pawlonia wood, where they are a tradition. As a child, she often watched workmen prepare the wood in the traditional method, which undoubtedly influenced her penchant for finding exactly the right material.

In 1982, she received her master's degree in architecture from the School of Engineering at Nihon University. She worked at architectural offices in Japan and abroad until 1989, when she opened her own operation. While working at Atelier Hollein, the office of Viennese Architect Hans Hollein, she was inspired by the way many avant garde artists and veteran craftsmen worked together as equals while maintaining their sharp individual sensibilities.

Kawaguchi has designed homes, hotels, showrooms, and other projects, including their interiors, and she designed both furniture and products while acting as instructor at her alma mater.

She did a one-man show of kiri furniture in Italia Milano Salone. Her designs always aim to be convenient yet advanced—a far cry from the throwaway products that seem to be today's norm.

Contact: Archistudio Kawaguchi
E-mail: arcka@attglobal.net
Related Website: http://pws.prserv.net/jpinet.arcka

Pages 18–19
WAVE BASKETS

S W22×D17×H5.5cm (W8$\frac{2}{3}$×D6$\frac{2}{3}$×H2$\frac{1}{8}$in.)
M W29.5×D21×H6cm (W11$\frac{1}{2}$×D8$\frac{1}{4}$×H2$\frac{1}{3}$in.)
L W45×D21.5×H6.7cm (W17$\frac{3}{4}$×D8$\frac{1}{4}$×H2$\frac{2}{3}$in.)

KAZUYUKI KUBO

Kazuyuki Kubo was born in Osaka in 1969. He worked for three years as a technician at an electronic parts maker, quit the company, and entered a vocational training facility in Beppu, Oita prefecture, with the objective of becoming a bamboo craftsman. He then became the apprentice of the late Kazuyuki Nonoshita, a renowned bamboo craftsman.

After a two-year apprenticeship, Kubo moved to Tachikawa in Tokyo to set up his own operation. He orders his material—matake lumber bamboo—from Kyushu. Bamboo products are made with thin withes produced by splitting bamboo, and the quality of the cut of the withes determines the quality of the finished product.

When he was an apprentice, at each year-end, Kubo's master would take orders for great volumes of green bamboo chopsticks for use at New Year meals. The master made Kubo go out into the groves to find, gather and split the bamboo in preparation for the master to make the chopsticks. And he had to make bamboo withes day in and day out, all year long.

"When I was an apprentice, I made bamboo withes every day. I have no idea how many tens of thousands of withes I made—so many that I could virtually do it in my sleep," Kubo says.

But the two arduous years of apprenticeship taught Kubo how to judge bamboo, and how to find bamboo

with precisely the right characteristics for the job to be done. "I'm still learning," says Kubo, "but someday I'd like to become a real master, someone who can come up with a new way to work in bamboo."

Contact: Kubotakekobo
E-mail: iccouikkou@ybb.ne.jp
Related Website: http://www.geocities.jp/iccouikkou/index.html

Pages 20–21
CALLIGRAPHY BRUSH

W4×L36, brush 11cm (W1½×L14⅙, brush 4⅓in.)

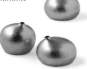

HIROKAZU TAZAKI

Hirokazu Tazaki was born in Hyogo prefecture in 1948. He now lives in an old house about an hour-and-a-half drive from the castle town of Himeji. He loves bamboo—and making paper from bamboo fiber and ladles for the tea ceremony. He does calligraphy with bamboo brushes he makes himself.

Contact: Gallery Terra
E-mail: terra@u01.gate01.com

Pages 22–23
KATAKUCHI/SAKE SERVER/KATAKUCHI
"Yakihada migaki no shuki"

From Left:
"Hiyokonoko" W11.3×D10.5×H8.5cm(W4½×D4⅛×H3⅓in.)
"Tamago no ko" W10.8×D10.5×H16.5cm (W4¼×D4⅛×H6½in.)
"Hiyokonoko" W10.7×D10.5×H7.5cm(W4¼×D4⅛×H3in.)

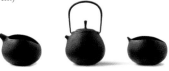

Pages 24–25
SAKE SERVER *"Yakihada migaki no shuki"*

"Tsuki o kofu" W20×D16×H15cm (W7⅞×D6⅓×H6in.)

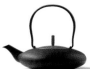

HISAO IWASHIMIZU

Iwashimizu was born in 1964 to a family of cast-iron craftsmen in Morioka, Iwate Prefecture. As a child, he played in the foundry among craftsmen busily applying their casting skills.

After earning a law degree at Nihon University, Iwashimizu became interested in design and went to work for a design studio. For three years, he worked in corporate identity design, before deciding he wanted to try new techniques at the family casting works. He joined the family company, Iwachu, a large foundry in Morioka that casts *nambu tekki* teapots, kettles, and other items. Later, he moved to Mizusawa to a nambu tekki workshop called Roji Associates. It was at these workshops that he went through a process of trial and error until he was able to perfect his technique.

Iwashimizu currently lives in Yokohama but commutes to the foundry in Mizusawa to cast his creations. He always tries to keep two things in mind: the concept of Mies van der Rohe—less is more—and thinking from the tea ceremony: *shuhari*, which means to learn the rules and always keep them in mind, even

when breaking them—part of the samurai training regimen of centuries past.

In 1998, Iwashimizu won Germany's Design Plus Award. Since 2000 his work has been offered for sale at the museum shop at New York's Museum of Modern Art.

Contact: Nippon Form
E-mail: nippon@mail-ozone.jp

Pages 26–27
IRON BOOKENDS

"Bookend K" W9.7×D6.5×H13.5cm (W3⅘×D2½×H5⅓in.)
"Bookend F" W9×D8.8×H17cm (W3½×3⅜×6⅔in.)

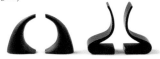

RIKUCHO OGASAWARA

Born in Mizusawa, Iwate Prefecture, in 1929, Rikucho Ogasawara was the son of a cast-iron foundry craftsman. At age 16, he went to work in a foundry operated by his father and a few other craftsmen. He learned his skills watching his father work, and three years later, he and his father started their own workshop. While in his twenties, he went to a seminar in Mizusawa given by Iwate Industrial Research Institute Crafts Manager Yoshikane Toda, which opened his eyes to new possibilities in design. Later, he went to Morioka to learn design from Toda, whose artistic talents included painting, literature, drama, tea ceremony, and cooking. After one of his tempura pots won an award in the Living Crafts Competition sponsored by the *Asahi Shimbun* some fifty years ago, Ogasawara began to travel often to Tokyo for exhibitions and shows. He concentrates on making items for household use: frying pans, fish pans, kettles, ashtrays and mosquito smudge pots.

Contact: Kagiroi
E-mail: contact@orientalspace.com
Related Website: http://www.orientalspace.com

Pages 30–31
IRON CANDLEHOLDER *"Kachikachi yama"*

Iron stand: W11.5×D3.5×H35cm (W4½×D1⅓×H13⅘in.)

KOZO TAKEDA

Kozo Takeda was born in Hirosaki, Aomori Prefecture, in 1950. He became interested in graphic design in high school, and worked as a designer part-time during his prep school years. Having saved enough money from his work, Takeda set off on a five-year bicycle tour of Japan, which allowed him to observe many types of architecture and sculpture before returning to Hirosaki, where he opened a small atelier. He entered a small basket woven from akebia vines in a competition, where it was well received. Then he entered a competition to develop products from *buna* beech with baskets made of string-like strips of buna. Again, his work was highly acclaimed.

Gradually Takeda's design business moved in a natural progression, he says, beyond individual items into designing retail outlets, and then furniture. He has never studied design professionally, relying instead on curiosity and study. "If there's something I want to make," he says, "I figure out a way to do it, and that becomes part of my storehouse of techniques. If you have ideas, you can find a way to execute them."

His work brings him in contact with a wide range of other professionals in many fields. In designing interiors for retail shops or homes, he puts together teams of his professional friends to execute the jobs, attempting to match the job perfectly to the skills required.

Contact: Yuzuriha
E-mail: info@yuzuriha.jp

Pages 32–33
BRASS VASES *"Ochobo-guchi no hanaike"*

From Left:
W8.5×H7.5cm (W3⅓×H3in.)
W9.2×H6cm (W3⅔×H3⅓in.)
W9×H7cm (W3½×H2¾in.)

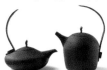

MIHO NISHIKAWA

Miho Nishikawa was born in Kanazawa, Ishikawa Prefecture, in 1979 and still lives there today. Nishikawa practiced classic ballet as a child, expressing herself through movement. She studied metal smithing at the Kanazawa College of Art and later trained in metalworking at the Utatsuyama Craft Workshop. She chose metal as her medium because of its permanence, its scarcity, and the fact that she can be involved in every aspect of metalworking, whether wrought work or sculpture. And that, she says, fits her personality.

Making hard metal look soft and inviting is enticing to Nishikawa. "Sometimes, when I'm handling metal, I marvel at how hard it is. At other times, however, it seems so soft and malleable. I find that dichotomy incredibly appealing," she says.

The artist wants to make things that are not everyday necessities, but improve the quality of life just by being there. "The people in Kanazawa really understand crafts," she says, "and they seem to have a tremendous capacity for it. My 25 years of living in this community have shaped the way I express myself. I'm thankful for the environment and surroundings in which I live, and try to reflect that in my work."

Contact: Miho Nishikawa
E-mail: miffo@syd.odn.ne.jp

Pages 34–35
IRON KETTLES *"Me"*

From Left:
W22×D15.5×H18.5cm (W8⅔×D6⅛×H7¼in.)
W17×D12×H23cm (W6⅔×D4¾×9in.)

HIROYUKI NAGASHIMA

Hiroyuki Nagashima was born in Tokyo in 1972 and raised in Kagawa Prefecture. He planned a career in product design while in high school, which led him to attend Kyushu Institute of Design. After college, Nagashima continued on to graduate school, where he studied interactive design, concentrating on product interfaces that users can easily understand.

In 1998, Nagashima entered the Iwate Industrial Research Institute in Morioka, Iwate Prefecture, where he supported local companies with a broad range of product and packaging design. Many companies, from artisans making Morioka's traditional cast-iron ware to mass producers, came to the institute for advice, and he was always eager to help. Nagashima's work often took him into foundries and workshops where craftsmen plied their trades. He had been interested in traditional crafts for some time, so he was more than happy with the opportunity to help develop products for those processes. "Some people get the

preconception that traditional crafts are bound by the traditional way of doing things," Nagashima says, "but in reality, the craftsmen's and artisans' way of thinking is always present, and sometimes they even get playful about something they're making.

"Form, detail, surface finishing—somewhere in each item you'll find a place where the craftsman's concerns take precedence and the piece becomes something only he could produce," Nagashima continues. "When I realized that and started to feel the same way myself, I began to respect the skill and commitment of those craftsmen. It's exciting to be able to find a small detail added by a craftsman that the casual observer might miss."

Nagashima now lives and works in Morioka. His work, "me," received the Overseas Training Prize at the 2004 Japan Craft Exhibition.

Contact: Nanbu Tekki Hanbai Inc., Kozan-Kobo
E-mail: kozan@mva.biglobe.ne.jp

Pages 36–37
TAPESTRY
"Washi Tapestry"

W80×H120cm
(W31 1/2×H47 1/4 in.)

Pages 38–39
BRANCH LIGHT "*Akari*"

W25×H45cm (W9 7/8×17 3/4 in.)

KAZUYUKI TOMI

Kazuyuki Tomi was born in 1972 in Wajima, Ishikawa Prefecture, the third generation of a family of papermakers. His grandfather made paper from the inner bark of cedar as well as from mulberry, and created a unique paper called *Notonigyoshi*, named after the region where the family workshop was located. The paper was used as wallpaper and for *fusuma* doors as well as wrapping. After his grandfather passed on, Tomi's mother, Kiyomi, continued the papermaking business. She created a beautiful paper called *Yashushi* by adding wild flowers during the paper-making process.

After graduating from high school, Tomi became an apprentice to Naoaki Sakamoto, a friend of his grandfather. Sakamoto traveled all around Japan searching for traditional local washi to sell in his paper shop, and owned an atelier in Niigata where he made his own paper. He also exhibited overseas and designed interiors using washi.

Tomi understood many of the basics of paper making, which he picked up playing around his family's workshop as a child. Under Sakamoto, Tomi studied the methods for making many different kinds of washi. But Sakamoto also taught him to overcome the prejudices that come with too strict a following of the basics and to become more flexible.

Today, Tomi is back at the workshop where he was raised. He makes the *Notonigyoshi* his grandfather developed, and creates a number of his own originals such as paper dyed with indigo or chestnut. He also makes large sheets of paper to meet the special orders of interior designers and architects.

Contact: Ecru+HM
E-mail: info@ecruplushm.com
Related Website: http://ecruplushm.com/

Pages 40–41
GIFT ENVELOPE AND
CHOPSTICK WRAPPING

Gift Envelope "*Ichimatsu-2*" W10.3×H18cm (W4× H7in.)

Chopstick Wrapping "*Hashi zutsumi*" W18.5×D4.7cm (W7 1/4×1 5/6 in.)

ORIGATA DESIGN RESEARCH INSTITUTE

The Institute, which was organized in 2001, consists of four graphic designers: Nobuhiro Yamaguchi, Midori Yamaguchi, Nana Komatsu, and Toshiharu Sakuma. In 2004, the group rented a small space in Tokyo, no larger than a *chashitsu* tea room, where they now base their operations. Their story began a dozen or so years ago, when Nobuhiro Yamaguchi came across an Edo-period book called *A Record of Wrapping*. The book showed how to wrap gifts in the warrior class way, compiled by the family in charge of protocol for the Edo Shogunate for passing on to further generations. The secrets involved in the wrapping had never been made public before the author, a scholar and member of the family, wrote his book.

Yamaguchi had wondered about the proper ways to fold and wrap items given on special occasions, and felt the book was probably the key. He began studying courtesy and protocol under Akihiro Yamane, an expert on the author. For three years he studied, and gradually his wife and several former colleagues became involved. With Yamane's blessing, Yamaguchi established the Origata Design Research Institute, which sponsors exhibitions and workshops, publishes books, and develops original products. These items use *Minogami* paper because it is thin and translucent. The Institute works with five young Mino papermakers to develop the paper: Shigetoshi Hoki, Takeshi Kano, Makoto Kurata, Mayumi Takahashi, and Minako Ieta.

Contact: Origata Design Research Institute
E-mail: yamaguchi@origata.com
Related Website: http://www.origata.com

Pages 42–43
KOYORI CONTAINERS

Box: W35×D27×H5cm (W13 4/5×D10 2/3×H2 in.)
Bowls: S W15.5×H7.5cm (W6 1/8×3 in.)
 M W21×H7.5cm (W8 1/4×3 in.)
 L W31×H8cm (W12 1/5×3 1/8 in.)

Pages 100–101
INKSTONE PLATES "*Suzuri*"

From top: W22×D12×H0.8cm, W10×D10×H0.8cm, W10×D2×H1cm (W8 2/3×D4 3/4×H1/3 in., W3 7/8× D3 7/8×H1/3 in., W3 7/8×D3/4×H2/5 in.)

RYOICHI KOBAYASHI

Ryoichi Kobayashi was born in Nagano Prefecture in 1949, and was raised in that inland province. After graduating from the Musashino Art University, he opened Studio Gala Kobayashi Design Office in Tokyo, where he designed everyday products with traditional materials. He also found time to teach at his alma mater.

Kobayashi created the koyori container series in 1984. He created the *Suzuri* concept for dinnerware after part of the slate roof of his house collapsed, and he had to find the same kind of slate to repair it. The craftsman who had originally laid the slate roof took him to a workshop that made roofing slate tiles, a process he found very interesting. He then went to the slate quarry in Miyagi Prefecture to see how they made the slate slabs. Seeing how they split slate horizontally give Kobayashi the idea for this product, which he designed and produced in 1985.

Contact: Studio GALA
E-mail: ryoichigala@jcom.home.ne.jp

Pages 44–45
LIGHTING OBJET "Kanose Museum Lighting Objet"

From Left:
W22.5×H72cm (W8 5/6×H28 1/3 in.)
W29×H38cm (W11 1/2×H15in.)
W25×H90cm (W9 7/8×H35 1/2 in.)
W34×H58cm (W13 1/3×H22 5/6 in.)

ERIKO HORIKI

Eriko Horiki was born in Kyoto in 1962. She worked in the accounting department of a company that developed washi products, where she learned of the harsh working conditions faced by craftspeople working in the medium. She marveled that such harsh conditions would result in product filled with such warmth. When the company folded, she decided to start designing interiors that used washi to enhance the space.

In 1987, with a silent partner, she established an office called SHIMUS to develop washi products. She knew that handmade paper could not compete with machine-made products in terms of price. And since the real value of long-lasting handmade paper become apparent only after long-term use, Horiki knew that this precious paper should not be used for throwaway consumables. But with interiors, items would likely be used until the next redecoration, so the advantages of handmade paper had the time to become readily apparent.

Horiki usually has her paper made in one piece, no matter how large an area it is to cover. The first time she ever had huge sheets of washi paper made was for the tea room of architect Masayuki Kurokawa, which required two sheets measuring three by seven meters.

When it comes to technique, Horiki is never bound by tradition. She comes up with new tools and new methods to get the job done. Architect Toyoo Ito requested her to make a washi egg, and she figured out a way to make a three-dimensional objet. This process, for which she has applied for a patent, was taught to local industry in order to mass produce the Kanose Museum Light Objet.

In 2000, she established Horiki Eriko & Associates Ltd. She has done the artwork for the arrival lobby of the No.1 passenger terminal at New Tokyo International Airport, the Expo Park VIP reception building, the Shanghai Westin Hotel, stage art for the Yo-Yo Ma cello concert at Carnegie Hall in New York, and others.

Horiki says washi has a mysterious power. It makes the unclean clean, and its depth goes to the very foundation of Japanese spirituality.

Contact: Okuaga Furusato Kan
E-mail: okuaga@smile.ocn.ne.jp
Related Website: http://www.okuaga.co.jp/furusato-kan/index.html

Pages 46–47

FOLDING SCREEN *"Sumi hiki zome byobu"*

W180×D180cm (W70⅚×D70⅚in.)

SACHIO YOSHIOKA

In 1946, Sachio Yoshioka was born to a Kyoto family of dyers whose history stretches back to the Edo period. After graduating in literature from Waseda University, Yoshioka established Shikosha, a publishing company dedicated to art books, and immersed himself in editing and studying art and craft history. He published many well-known art books, and became involved in advertising art direction.

In 1988, he returned to his family business to become the fifth generation of dyers at Somenotsukasa. The company concentrated on plant dyes, extracting colors from flowers, trees, and other plants, to dye yarn, silk, etc. The firm was also historically involved in dyeing items for such famous temples and shrines as Todaiji, Yakushiji, Kasuga Taisha in Nara and the great shrine at Ise.

Yoshioka worked hard at recovering and replicating ancient dyeing methods, and recreated flags and *gigaku* musician costumes for troupes in Nara. He also made Tang Dynasty Chinese banners patterned after those from archeological digs at Dunhuang. Moreover, Yoshioka published the results of his in-depth studies as *Nihon no Iro Jiten* (Dictionary of Colors of Japan), which documented 466 different colors from plant-based dyes. Wearing his art director's hat, Yoshioka designed the wall behind the subway platform at Tameike Sanno Station with a motif taken from Kyogen costumes.

For Horyuji's commemoration of 1380 years from the death of Shotoku Taishi, Yoshioka enlisted the assistance of master weavers and recreated the *Shishikari-monnishiki* pattern that is a Horyuji tradition.

Contact: Somenotsukasa Yoshioka
E-mail: azabu-yoshioka@abelia.ocn.ne.jp

Pages 48–49

WOOD-GRAIN STATIONERY *"Itame gami"*

W17.3×D12.2cm (W6⅘×D4⅘in.)

YOSHIFUMI OKATSU

Yoshifumi Okatsu was born and raised in Tosa, Kochi Prefecture, in 1951. Okatsu's grandfather began making paper near the banks of the Niyodo River, so he is the third generation of papermakers in his family. He studied industrial sciences in high school, then worked for an Osaka adhesives company. At the age of 22, he returned home to join the family business, which included making paper for *shoji* doors and calligraphy. But sadly, the family-made calligraphy paper was losing out to low-priced products from China, and machine production became the rule for door paper. Okatsu went to the Kochi Prefecture Paper Technology Center for futher study, and took the center's advice to develop unique paper products for his family business. Some of the ideas he came up with included

making paper for woodblock printing, paper to use when renovating important cultural properties, and paper for hanging scrolls.

Okatsu's wood-grain paper is a natural part of making paper for woodblock prints. The paper is made of *mitsumata* fiber mixed with fiber from Egyptian esparto grass to give it a softer texture. He makes the paper using the rare *tamesuki* method, putting the wet paper on pine planks that have had the pitch removed so the wood grain stands out and transfers to the paper.

Okatsu was president of the Kochi Prefecture Association of Handmade Washi Papermakers and as such was interested in helping activate local industry. Okatsu met Yuko Yokoyama some 20 years ago, and as he didn't get a chance to go to Tokyo, her opinions on urban demand were especially valuable.

YUKO YOKOYAMA

Yuko Yokoyama was born in Chiba Prefecture but lived in Hyogo Prefecture since the age of four. At university, she studied English literature and went to work for the sole representative in Japan for Tiffany Company. After leaving the company, she went to New York, where she produced corporate literature, advertising, television programs, videos, and films for Japanese companies. During this time, in search of her own identity, Yokoyama studied the history and methods of Japanese traditional crafts. This led to a book called *Japanese Crafts*, which was published by Kodansha International.

Upon her return, Yokoyama settled in Tokyo and became involved in publishing and event production, especially programs that set up cultural exchanges between Japan and the United States.

Hoping to stimulate international-mindedness among traditional craftspeople and create demand for Japanese crafts abroad, Yokoyama helped establish two organizations: the Study Group for the Internationalization of Traditional Crafts and the International Forum for Traditional Crafts, serving as their executive director. One of the projects was a symposium on the theme of "Considering the Future of Tosa Washi." She visited the area during preparation, where she met Yoshifumi Okatsu. She was entranced by his wood-grain paper, which absorbs ink well and yet holds the wood-grain embossing.

Yokoyama is now researching the traditional crafts of Thailand and of Vietnam's indigenous mountain people, with an eye toward developing new products. In 2000, she created a Web site in Japanese and English that introduces traditional crafts.

Contact: Johmon-sha Inc.
E-mail: shop@handmadejapan.com
Related Website: http://www.handmadejapan.com/

Pages 50–51

ORNAMENTAL BOWLS "FLOWER"

W51×D32×H10cm (W20×D12½×H3⅞in.)

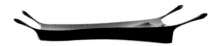

Pages 52–53

"FLOWER"

Top: W43×D23×H16cm (W16⅞×D9×H6⅓in.)
Bottom: W29×D23.5×H19cm (W11⅜×D9¼×H7½in.)

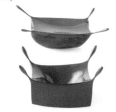

SEIICHIRO FUJINO

Seiichiro Fujino was born in Hikone, Shiga Prefecture, in 1972. He studied lacquer techniques at the Kanazawa College of Art and graduate school. He chose the field because he was fascinated by the combinations of materials—lacquer on wood, lacquer on metal, gold or silver dust on lacquer in *maki-e* techniques, and so on. Depending on the work, lacquer can play the major role, or the item being lacquered can be most important. Fujino says that flexibility is part of what drew him to lacquering as a career.

After finishing graduate school, Fujino worked for a Tokyo model manufacturer, but quit a year later to become involved in lacquer full-time. He moved to Kanazawa where he spent three years training at the Utatsuyama Craft Workshop. During that time, he was recognized for his work at public exhibitions. He also held private showings of his work in Tokyo, and gradually gained a reputation. He now lives in Kahoku, Ishikawa Prefecture, where he has an atelier. Ishikawa is home to many talented lacquerists, so it is an excellent environment for the craft—allowing Fujino to visit the roots of lacquering to learn traditional techniques all over again. His goal is to be the best with traditional techniques.

Recently, Fujino joined forces with another modern lacquerist to hold a two-man exhibition at the Kanazawa 21st Century Museum of Contemporary Art Design Gallery, and he is currently preparing for his next show. His work, "Flower," received the Grand Prix at the 2004 Japan Craft Exhibition.

Contact: Seiichiro Fujino
E-mail: pujino@po4.nsk.ne.jp

Pages 54–55

STACKED DINNER BOXES *"Sumi-iro no jyubako"*

W30×D26×H33.5cm (W11⅘×10¼×13¼in.)

YASUYO IZUMI

Yasuyo Izumi was born in 1950 in Yokohama. After earning a degree in graphic design from Tama Art University, she worked as an art director for food advertising. In preparing food for photography, she came in contact with lacquerware, and decided she wanted to create lacquered items herself. She met master lacquer artist Toshihiko Takahashi, and asked him to teach her. "If you want to become a professional, I'll teach you," he told her, "but if you think of lacquering as a hobby, I won't." So Izumi quit her graphic design job and apprenticed herself to Takahashi at the advanced age (for an apprentice) of 31. "You're starting late," he said, "so you don't have time to do all the hard labor that apprentices usually have to do." He proceeded to teach her only what she needed, without the trappings, and she was able to gain from him the true depth of lacquer work and lacquering techniques. Three years later, she opened her own atelier in her home in Tokyo. Her reputation soared when her work won the Grand Prix at the 1986 Japan Craft Exhibition.

1987 Participated in Art Horizons, an international competition held in the United States
2000 Exhibited at Monash University's Way of Working exhibition in Melbourne, Australia
Permanent exhibition at the Kumamoto Craft Museum.

Contact: Ecru+HM
E-mail: info@ecruplushm.com
Related Website: http://ecruplushm.com/

COLOR TRAYS "quatto"

W31×D31×H1.5cm (W12$\frac{1}{5}$×D12$\frac{1}{5}$×H$\frac{2}{3}$in.)

Pages 58–59

STACKED CUPS "ci-nic"

W7.2×H11cm (W2$\frac{4}{5}$×H4$\frac{1}{3}$in.)

MAKOTO KAWAMOTO

Makoto Kawamoto was born in Hyogo Prefecture in 1965. After graduating from Osaka University of Arts, he went to work for a design company in Tokyo, doing architecture and interior design. In 1992, he moved to Milan, where he worked for another architectural firm. He opened his own studio there in 1995, and came up with the idea of collaborating in lacquerware design. He considered lacquerware the most uniquely Japanese of Japan's traditional crafts, even though it was not well known in Italy. He decided he wanted the products done in Kawatsura, Akita Prefecture, which is not a high-profile lacquer-producing area (perhaps making them more open to change). He went to Kawatsura to explain his product ideas. At first, the local artisans were cool to his concepts, but after a few months, some said they'd give the new products a try.

Kawamoto is not the only designer involved; he has enlisted eight Italian designers to collaborate on the project. Kawamoto tells them, "Don't worry about the techniques or technology, just think about how you want to show the material." He wants to break the rules of traditional lacquerware design and production methods, because he believes that it utilizes set methods to do a set range of similar products.

KOH SATO

Koh Sato was born in 1962 in Kawatsura in Akita Prefecture. Local lacquerware traces its roots to the medieval period, but most people think of Kawatsura ware as items made for everyday use. Sato is a second-generation Kawatsura lacquerware artisan. After graduating from high school, Sato joined his father, helping run the family lacquerware shop and working in the atelier. They created tea ceremony items, tableware, furniture, and other lacquerware, and sold them from the family shop.

Sato heard Makoto Kawamoto's ideas and agreed to make some samples for him. He asked his lacquer artisan friends to help: wood lathe artisan Toshiro Miyama; *sashimono* cabinetmaker Kenichi Taki; *maki-e* artisans Kazuo Sasaki and Shinsaku Ozeki; and lacquerist Kenichi Takahashi. The project also received some public funding.

When he got the first drawings from Kawamoto, Sato was surprised and confused: at the very least, the design ignored the principles of quick production. But those involved began to consider it a challenge: "They were interesting designs, something the world of lacquerware has never done," Sato now says.

The completed items were exhibited in Italy to wide acclaim, and new business opportunities have opened as a result. Some 20 products have been made to date, ranging from tableware and small furniture to jewelry, and today the team produces about five new products a year, made from designs sent from Kawamoto in Milan..

Contact: Ecru+HM
E-mail: info@ecruplushm.com
Related Website: http://ecruplushm.com/

Pages 60–61

POP ART SAKE SET "*Kanshitsu*"

Left & Center: W5.7×H4.2cm
 (W2$\frac{1}{4}$×H1$\frac{2}{3}$in.)
Right: W7.2×H12.5cm
 (W2$\frac{4}{5}$×H4$\frac{7}{8}$in.)

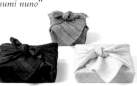

JUN TAKEDA

Jun Takeda was born in Aizu Wakamatsu, Fukushima Prefecture, in 1972, and grew up in the area, which is famous for its lacquerware. Both Takeda's father and grandfather were skilled *maki-e* craftsmen who produced many of the city's fine lacquerware products.

In high school, Takeda studied interior design, concentrating on lacquer work. After graduation, he spent 10 years at the Aizu Center for the Development of a New Generation of Lacquer Artisans, where he honed his skills to become one of the area's top lacquer artisans. While continuing to produce the traditional *maki-e* lacquerware made by his family, Takeda began to experiment with items that transcended the tradition. These new items won awards in the Aizu-nuri lacquerware competition, and Takeda, with his father's blessing, quit the family business to establish his own atelier.

Takeda creates only the lacquerware that pleases him, a policy that has forced him to take on other work to help pay the bills. He says he wants to leap beyond everyday items, and he has. But Takeda says the odd appearance of his works is really founded on strict adherence to traditional methods of lacquerware production.

The items here are part of an on-going series of items based on PET bottles and soft drink cans. He hopes to hold a private exhibition of these items in the near future.

Contact: Jun Takeda
1–20 Babamotomachi, Aizuwakamatsu-shi
Fukushima, Japan

Pages 62–63

TAPESTRY "Indigo Cascade"

W180×L180cm (W70$\frac{5}{6}$×
 L70$\frac{5}{6}$in.)

Pages 64–65

TAPESTRY "*Ranryusenmen*"

W180×L200cm (W70$\frac{5}{6}$×L78$\frac{3}{4}$in.)

MINORU ISHIHARA

Minoru Ishihara was born in Tokyo in 1951. He opened his dye works in Tokyo's Ota ward in 1979.

As a child, Ishihara loved to draw, and his favorite book was one by Hungarian philosopher, writer, and film critic Béla Balázs. It is a story about a poor boy who borrows some sky-blue paint from his friend and then loses it. But a strange old man teaches the boy how to make sky-blue paint from indigo plants, and after drawing a picture of the sky with the paint, he watches as the sun rises in his freshly painted sky.

In 1970, Japan was in the throes of political turmoil and students were rioting in the streets—they were turbulent times that made Ishihara want to do something with his hands. He says imagining the magic paint from the story always made him happy and full of life, and he believes that it was really Balázs' book that made him choose to start as a dyer 25 years ago, and eventually make it his life's work. It was the magic indigo in that story, he says.

He also read and treasured the works of Kenji Miyazawa, a poet who once said, "The water and the light and the wind are all part of me." He had great respect for the author's lifestyle, especially the way he interacted with nature and the sensitivity to color he learned from his natural surroundings. Actually, the marbling of Ishihara's work reflects natural phenom-

enon in much the same way Miyazawa's world fused with nature. Ishihara says he feels a resonance between his own work and that of Mother Nature.

Contact: Nori Gallery
E-mail: n@norigallery.com

Page 66–67

TAPESTRY "For the living things in the arctic circle"

W22.5×H75cm (W8$\frac{5}{6}$×H29$\frac{1}{2}$in.)

SACHIKO YATANI

Sachiko Yatani was born in Okayama Prefecture in 1957, but raised in Tokyo. After graduating from Musashino Art University, she worked for 10 years as a corporate textile designer. Then she began to weave textiles from yarn she taught herself to spin from natural wild plants, vines, ramie, hemp, and nettles. Each summer, she visits the mountains near her parents' home in Nakaizu, Shizuoka Prefecture, where she harvests plants to make her yarns and takes them back to her atelier in Hayama, Kanagawa Prefecture, where she weaves them into textiles.

Ten years ago, when she first started the process, the plants for her yarns were plentiful. Since Yatani does not cultivate any of the plants for her yarn, preferring to find them in the wild—and with people today always trying to get rid of wild plants—her materials are getting more and more difficult to find. It is hard work to gather them, but on the other hand, each year she says she meets up with new plants she can gather and use, which is always a pleasure. Nature dictates how she gathers her materials, but that also gives her peace of mind. She says the tiny flickers of power residing in the wild plants are what really weave her textiles.

"I've seen movies about orangutans, which live in the rain forests of Indonesia, making beds from leaves and using large leaves as umbrellas to protect them from the rain. Like the orangutan, I like to use the plants that exist around me, the plants that seem so everyday, to make something useful. The plants taught me what to do. They taught me what the earth has learned through thousands of years of existence. Humans must have been doing things this way long ago, when we were still people of the forest," she says.

Contact: Sachiko Yatani
E-mail: xusa_s@ybb.ne.jp

Pages 68–69

FUROSHIKI "*Tsutsumi nuno*"

Gray: 74×74cm
 (29$\frac{1}{8}$×29$\frac{1}{8}$in.)
Natural: 67×67cm
 (26$\frac{1}{3}$×26$\frac{1}{3}$in.)
Indigo: 75×75cm
 (29$\frac{1}{2}$×29$\frac{1}{2}$in.)

KAORI MAKI

Kaori Maki was born in Toyama Prefecture in 1962, but grew up in Musashino, Tokyo. Even in her childhood, Maki showed an interest in colors. She studied textile design at Rhode Island School of Design in the United States, then worked for three years as a textile designer for large companies in New York, Kyoto, and Bangkok, before returning to Tokyo. She now designs and creates textiles at the Maki Textile Studio, owned by her older sister Chiaki Maki, and also works in her own atelier in the Yatsugatake highlands of Yamanashi Prefecture, where she moved three years ago. Together with her partner, Maki built a log house from Finnish pine in a place called Nishikabura. She took one portion of the place name and christened her workplace Kabura-no-Mori Studio.

In spring, she tills the fields and plants seeds. In fall, she enjoys the harvest, splits firewood, and gath-

ers small branches. In winter, with snow covering the ground, Maki lives indoors, winding yarn and thread dyed with bark, plants, nuts, and fruits of the seasons, and plying her loom.

From her window, she watches wild animals, deer, foxes, squirrels and countless birds. She believes there is a great deal to learn by watching the forest and how it adapts to the seasons, and by fitting her work to the rhythm of nature, she lets the forest dictate her lifestyle.

Contact: Kabura no mori Studio
E-mail: kabura-s@mx2.nns.ne.jp

Pages 70–71
ZABUTON

S 50×43cm (19²⁄₃×16⁷⁄₈ in.)
L 65×45cm (25¹⁄₂×17in.)

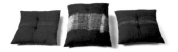

MIHO USUTANI

Miho Usutani was born in Yokohama in 1959. After graduating from a textile institute, she went to work for a textile import-export company. Usutani decided she wanted to design textiles and quit the trading company after two years. She then began to study under Junichi Arai, an internationally known textile designer. At Arai's studio, Usutani was involved in the development of material for the Paris Collection of fashion brands such as Issey Miyake and Comme des Garçons. In this process, she says she learned firsthand how difficult the creative process is yet how satisfying it is when done successfully. When Comme des Garçons wanted to create a collection on the theme of ethnic native costumes, Arai started indigo dyeing in the studio, which is where Usutani first came in contact with the traditional process.

Also about that time, she came in contact with legendary creator Soetsu Yanagi's philosophy of "folk craft." Yanagi believed that it was the repetition of the same process that ultimately results in superior products, and this thinking helped Usutani learn about the world of traditional craftsmen.

In 1984, she set up her own vat in Ota, Gunma Prefecture, and began producing items, mostly dyed with indigo. Some years later, her indigo-dyed creations won awards at two different competitions, and she became known as a dyer more than as a weaver. Today, in fact, most of her work is dying.

In 1998, with a grant from the Japan Foundation, Usutani held an exhibition of her work at a gallery in Germany. She moved her atelier to Hayama, Kanagawa Prefecture, in 2000.

Usutani says, "To me, indigo blue is a color that means silence and peace. Not only does it impart wellbeing and strength to the eyes, but it also speaks to the heart. It feels like the place where the spirit always returns in the end."

Contact: Ecru+HM
E-mail: info@ecruplushm.com
Related Website: http://ecruplushm.com/

Pages 72–73
TAPESTRY "2004–021"

L237×W47cm (L93¹⁄₃×W18¹⁄₂ in.)

MASAKO MORYO

Masako Moryo was born in Iwate Prefecture in 1961. While at Iwate University's College of Education, she considered studying sculpture, but she felt her physical strength placed limitations on her abilities. She was not interested in cooperative efforts, so she chose dyeing and

weaving. Moryo wanted to pursue self-expression beyond the confines of fine art, and weaving was an area where she could create stoles and tapestries and other items while doing something she truly enjoyed. For two years, she worked in the atelier of the late Hironao Arikawa, master of homespun and broad-loom weaving, learning his techniques. Now Moryo creates her magic in a studio in her own home.

She weaves with the materials that suit her fancy—wool, silk, cotton—and as urge strikes. She feels that the item dictates the final choice, and is as willing to use synthetic dyes as well as natural ones if that adds to the appeal of the item she creates. But she admits there is an environmental consideration involved when she must cut trees or wash excess dye from her textiles. Moryo says it is important to realize that to make something, something else must be destroyed.

About this piece, Moryo says, "A friend who saw this work said it looked like a fishing net. When I was young, I used to think the fishing nets hung to dry in the sun were beautiful, so perhaps that scene in my heart was transferred to my work without me really thinking about it."

Contact: Yuzuriha
E-mail: info@yuzuriha.jp

Page 74–75
STAINLESS STEEL CLOTH "Stainless Stole"

L140×W35cm (L55⁷⁄₈×W13⁴⁄₅in.)

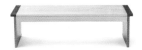

NOBUE SAITO

Nobue Saito was born in Sendai, Miyagi Prefecture in 1961. She developed an interest in graphic arts at an early age, and at Iwate University's College of Education, she learned weaving with an emphasis on homespun Morioka wool and other hand-spun fabrics. After graduation, she stayed on to audit courses for three years, then returned to her family home in Sendai and began to weave textiles.

She spun by hand, making a wide variety of yarns, and says spinning is intriguing in and of itself. Besides wool and silk, she uses stainless steel wire woofs with wool warps or paper with copper or stainless, weaving materials of different characteristics together to make more interesting creations. When materials of different characteristics are woven together, she believes, something entirely new appears.

Saito uses native plants such as lambs quarters, evening primrose, and sorrel root to dye silk, but colors wool with synthetic dyes. She uses steel for many items but also makes tapestries and lighting fixtures.

After marriage, Saito moved with her husband when he was transferred to Aomori and then Kuroishi, both in Aomori Prefecture. She currently lives in Niigata, Niigata Prefecture. Every time she moves, she takes along her favorite spindle and loom, and believes that meeting new people, experiencing new climates and weather, and learning new traditions help her make new and more interesting creations.

Contact: Yuzuriha
E-mail: info@yuzuriha.jp

Page 76–79
NOMADIC CHEST "Kobiki Chesuto"

W109×D36×H60cm (W42⁷⁄₈×D14¹⁄₅×H23²⁄₃in.)

RYOHEI KIDO

In 1961, Ryohei Kido was born in Mito, Ibaragi Prefecture, where he was raised. After graduating from university, he joined a newspaper in Morioka, Iwate Prefecture. While working for the paper, Kido met Yoshio Yotsuya, a maker of shoji and fusuma doors. After four years at the newspaper, he quit and became Yotsuya's apprentice, but the master craftsman passed away only three months later. With a family to care for and no job in sight, Kido was devastated. But he gathered himself together and went to carpentry school, where he spent a year learning how to repair and renovate homes. Then he spent a year at a company that produced cabinetry, doors, and sashes for homes. During that time, he spent his spare hours at antique shops in Hanamaki, inspecting funadansu, kurumadansu, and other tansu chests from the Edo Period. As time went on, owners of antique shops began asking Kido to refurbish their antique chests.

In 1992, Kido came across an 80-year-old farmhouse in Shiha. He moved into the big house, which was surrounded by orchards, fields, and groves of trees, and opened a workshop, where he reproduces painstaking replicas of Edo-period funadansu and kurumadansu. He makes funadansu with clockwork locking mechanisms that he designed himself. He also makes modern stools, seats for Japanese style sitting, tables, desks, and other highly regarded pieces of furniture. "I have no master," Kido says, referring to his truncated apprenticeship, "so antique wood chests are my masters. By refurbishing them, I was able to learn."

Contact: Tansu Kobo Hakoya
E-mail:tansuhakoya@ybb.ne.jp
Related Website: http://iwate.info.co.jp/hakoya

Pages 80–81
FOLDING DESK "FEB."

W105×D42×H31cm (W41¹⁄₃×D16¹⁄₂×H12¹⁄₅ in.)

YOSHIFUMI NAKAMURA

Yoshifumi Nakamura was born in Kujukuri, Chiba Prefecture, in 1948, where he also spent his childhood. After graduating in architecture from Musashino Art University, he enrolled in Tokyo's Shinagawa Training Center to learn the craft of making wooden furniture. Beginning in 1977, Nakamura spent four years as an assistant and furniture designer for architect Junzo Yoshimura. In 1981, Nakamura established his own company, Lemming House, designing homes and furniture. Nakamura won the First Yoshioka Award for his "Mitani Residence," and a special award in the 18th Isoya Yoshida Awards. He is also a professor of architecture at Nihon University's School of Industrial Technology, and writes extensively about housing, home architecture, and furniture.

About his furniture, he says:"Above all, I wanted to work in something that put me in direct contact with people's lives. I wanted to be able to see it all—to hold it in the palm of my hand, so to speak. If anyone were to ask where I learned to design furniture, I would say without hesitation, 'the woodcraft and furniture of the American Shakers and Korea's Ri Dynasty.' I've seen their actual furniture and I've read about it in books, and learned of the superior functionality and efficiency of their form, firm structure, and set proportions. And beneath it all runs sensitivity and polish that almost goes beyond mere sophistication. In addition, I was blessed with compatriots and colleagues who loved and were passionate about furniture. Each of my furniture designs represents total cooperation and meeting of the minds between myself and a master woodworker."

Contact: Lemming House
E-mail:chuchu@lemminghouse.com

Pages 82–83
L-SHAPED PLATES

W24×D24×H4cm (W9½×D9½×H1½in.)

RYUJI MITANI

Ryuji Mitani was born in Fukui, Fukui Prefecture in 1952, and raised in the same city. He studied literature at university and joined a Kyoto theater group where he made posters for performances and presentations and built stage props. He quit the theater group to travel, and after a visit to the city of Matsumoto, he decided to stay for six months learning woodworking at a vocational training school.

He opened Persona Studio in one room of his apartment in 1981 where he made accessories of wood. Later, stimulated by a friend who made furniture, Mitani started thinking of making things connected to everyday living and began making wooden tableware in the same manner as potters used clay.

Mitani later moved his workshop to a farmhouse in the outskirts of Matsumoto. He rebuilt a shed to the design of architect Yoshifumi Nakamura in a location surrounded by apple orchards and open fields. He turned a former stable into a woodworking shop and a drying room into his lacquer workshop.

Beginning in 1985, Mitani and several friends planned and put together the annual Craft Fair Matsumoto, at which crafts for everyday use were exhibited. With each craft fair, they publish a newsletter called *Mano*, which Mitani edits.

Mitani creates sculptures in wood as well as flat items, including wooden covers for novels. His creative activities even extend to illustrations as well as writing articles for magazines.

Contact: Persona Studio
E-mail: wood@mitaniryuji.com
Related Website: http://www.mitaniryuji.com

Pages 84–85
PORTABLE SEATS

Back row, from left: "*Teiza-isu*" W32.5×H9.8cm, "*Seiza-isu*" W24×H11.8cm, "*Seiza-isu*" W18×H13.8cm (W12⁴/₅×H3⁷/₈in.,W9½×H4²/₃in.,W7×H5½in.)

Front: "*Zabuton*" W32.5×H2cm (W12⁴/₅×H³/₄in.)

TAIICHI KIRIMOTO

Taiichi Kirimoto was born in Wajima, Ishikawa Prefecture, in 1962, and raised in the same town. He studied product design at Tsukuba University's College of Art and went to work for a major office supply company. Kirimoto's studies at university and his work experience convinced him that in an age of throwaway products, there is still much value in items that can be used again and again. He decided that, for him, products of wood painted with lacquer were a great possibility to improve and enhance lifestyles.

He returned to his family, which had been doing magnolia woodwork for lacquerware for 70 years, where he served as apprentice, learning to work not only with magnolia, which grows in the Wajima area, but also with other wood, to serve as base for Wajimanuri lacquerware. After that, he went on to design and produce tableware, furniture, and interior finish woods. Participating in competitions and holding private exhibitions in Tokyo, he slowly gained a reputation, and he was asked to teach university courses and write articles.

"According to data announced in 2000, tests conducted by the Kyoto Lacquerware Association showed that when food is left on lacquerware for four-and-a-half hours, E. coli 0157 and MRSA bacteria are reduced by half, and within 24 hours, the bacteria is completely eradicated," says Kirimoto. "I think the ancients knew that lacquerware stacked boxes had antibacterial qualities. I want to continue to praise and respect the beauty and the warmth of the unique combination of wood and lacquer."

Contact: Wajima Kirimoto/Kirimoto Mokkosho
E-mail: houkiji@big.or.jp
Related Website: http://www.kirimoto.net

Pages 86–87
OAK CHAIR "Arm B-1"

From the side: W51.5×D61.3×H73.5 (SH40)cm (W20¼×D24⁷/₈×H29 (Seat height: 15³/₄in.)

TOSHIHIKO YANAGIHARA

Toshihiko Yanagihara was born in Shimane Prefecture in 1961, and raised in Yonago, Tottori Prefecture. Since his childhood, Yanagihara used hammers and nails and

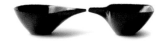

pieces of wood as his toys—he was always making something. He had decided upon a career in woodworking while still in grammar school.

He spent nine years honing his skills at a Yonago firm that produced custom-made furniture, before learning of a craftsman in Matsue famed for his woodworking expertise. Yanagihara traveled there and convinced the man to take him on. He worked there for three and a half years, enjoying himself and his work as he learned a new way of life and a new aesthetic.

With the woodworker's agreement, Yanagihara began looking for a place to set up his own workshop. Fortunately, he found a large building that was once a silkworm hatchery, where he opened his furniture workshop Green Woods in 1993. The front door of the workshop overlooks a mountain scene, and the fields that formerly grew mulberry to feed silkworms are now filled with plum trees. To Yanagihara, it's the ideal environment.

Yanagihara makes custom-designed furniture: "Woodworking is really a matter of looking at yourself. In your work, you soon come to see yourself, and you begin to be able to express who you really are."

Contact: Green Woods
FAX: 0859-68-4585

Pages 88–89
BENCH "Used Wood Bench"

W130×D45×H60cm (W51¹/₅×D17³/₄×H23²/₃in.)

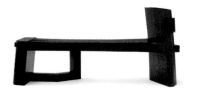

SHINJI HONGO

Born in Fukuoka Prefecture in 1968, Shinji Hongo was raised in Yokohama. Even as a child, he liked to paint pictures and make things. At Tokyo National University of Fine Arts and Music, he majored in design, and went on to study sculpture in graduate school. He joined a lighting fixture company after graduate school, where he designed lighting for retail outlets. Wanting to create his own works, however, he quit after two years.

He then spent three years as an untenured instructor at his alma mater, and worked in his home studio creating abstract sculptures from waste materials. He entered his creations in exhibits and held one-man shows of his works.

In 1998, two newspapers ran articles about his style of work using waste materials, and his difficulty finding materials. As a result, more than 100 people wrote from all over the country telling him of houses scheduled for destruction or offering him materials from a recently demolished home. About 50 were within easy driving distance, mostly in the Tohoku area, so Hongo made the rounds to pick up the waste lumber he needed. The old lumber—from farm houses more than 100 years old and family homes over 50 years old—was perfect for his needs. Hongo says he now has enough to keep him creating objects for the rest of his life.

About three years ago, he found a new means of self-expression. In addition to abstract sculpture, which has no practical use, he began using the discarded wood to create modernistic objects that were also useful as practical furniture. His shows and exhibitions frequently feature both types of works. His work, "Used Wood Bench," received an award at the 2004 Japan Craft Exhibition.

Contact: Shinji Hongo
E-mail: peaworks-h@s3.dion.ne.jp

Pages 90–91
KATAKUCHI

From left: W19×D13×H7cm, W17.3×D13.5×H7cm (W7½×D5⅛×H2³/₄, W6⅘×D5¼×H2³/₄in.)

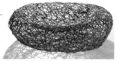

MITOMU YAMAMOTO

Mitomu Yamamoto was born in Kamakura in 1945 and raised in that historic city. After design school, he joined an advertising production company, where he did graphic design and illustrations. He liked to fish, and spent most of his days off out on the ocean in fishing boats. During inclement weather, when he could not go fishing, he often found himself carving fish from wood. Working with pieces of *hinoki* wood obtained from building sites, he used saws and chisels and hammers to create his carvings. He later became interested in tableware and began carving these items as well. He read up on the *fuki-urushi* lacquering method and taught himself the technique.

Since he had a full-time job, Yamamoto spent his early mornings, late nights, and days off carving. He began entering and winning competitions, including the grand prize in one event. Then, to build up his physical and spiritual strength, Yamamoto began to practice *kyudo*, Japanese archery.

He now resides in Zushi, and built a small workshop by the side of the railway where no one would be bothered by the noise he makes when rough-shaping wood with power saws or other tools. He finishes his works at home.

In 2005, Yamamoto retired and now carves full time. Besides tableware, he makes stools, benches, tables, and other furniture. Some day, he says, he'd like to carve a statue of a human figure.

Contact: Ninnin Kobo
FAX:046-872-0483

Pages 92–93
BASKET "*Midare*"

W40×D35.5×H13.5cm (W15³/₄×14×5¼in.)

MASAKO MAKI

Masako Maki was born in Tokyo in 1936 and raised in the city. From her youngest years, she loved

flowers, and studied flower arrangement. As many of her arrangements were put in baskets, she gradually became interested in those as works of art as well. When visiting her husband's hometown of Nozawa in Nagano Prefecture, she noticed farmers weaving baskets of akebia vines in their spare time. The children would weave the easy parts and their parents and grandparents would take over to do the more difficult portions. Maki became intrigued with their basket weaving and visited Nagano many times to learn the technique. She liked knitting anyway, and loved weaving vines. Before long, she was spending more time weaving baskets than arranging flowers.

She learned of several master craftspeople in Tokyo's Taito Ward who wove rattan baskets using traditional techniques. She began to study with these masters, visiting time after time until she'd learned their methods.

Maki saw beautifully woven European baskets in magazines from overseas, and imported them for herself, took them half apart, and learned how to weave them by putting them back together again. She also traveled to the outskirts of Paris to enroll for a short course in basketry design at the Claire Art School. She hoped to combine the Japanese akebia weaving techniques with European basketry design to create something entirely new.

She was part of a group exhibition of baskets at the William Lipton Gallery in New York in 1998, and her baskets were featured in a *New York Times* article. Maki lives in Tokyo's Koganei city; she has a workshop and classroom near her home where she works on baskets, teaches basketry, and writes on basket weaving techniques.

Contact: Maki Textile Studio
E-mail: studio@itoito.jp
Related Website: http://www.itoito.jp/en/index-e.html

Pages 94–95
SPHERICAL BOWLS *"Wan"*

Back row, from left: W10×H7cm, W10×H7.5cm, (W3⅞×H2¾in., W3⅞×H3in.)
Front, from left: W7.2×H5cm, W7×H5cm, W7×H4.5cm (W2⅞×H2in., W2¾×H2in.,W2¾×H1¾in.)

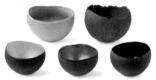

SEIJIRO TSUKAMOTO

Born in Tokyo in 1944, Seijiro Tsukamoto spent the war years in Ishioka, Ibaragi Prefecture, only returning to Tokyo when he was seven. As a freshman at Tokyo National University of Fine Arts and Music, he chanced upon an exhibition at the National Museum of Modern Art featuring the works of modern potters from Japan, Europe, and the United States. His preconceptions concerning ceramics were wiped away, and he began to concentrate on pottery throughout his years at university and graduate school.

After graduation, Tsukamoto went to work for a ceramics workshop in Izu. As he worked, he looked for a place to build his own kiln, finally settling on a place in the town of Minami Izu, where he spent three years finishing his home and his kiln.

In addition to ceramics, Tsukamoto builds tables and chairs of wood and steel, creates light installations and does exhibitions on a regular basis. "Why do I work in materials besides clay? Look, there's a bottle on the table and the light is coming through the window. There's a chair and a table, and a picture hanging on the wall—it's all one scene from my life. I'd like to turn its nuances into tangible items. Maybe that's why," Tsukamoto says.

Contact: Atelier Dan-Kobo, Seijiro Tsukamoto
E-mail: dan-kobo@hotmail.com

Pages 96–97
TRAYS AND MAT

From second from left:
13×13cm, 23×23cm, 36×26cm (5⅛×5⅛in., 9×9in., 14⅛×10¼in.)

YUKIKO IWATANI

Yukiko Iwatani was born in Hokkaido in 1958, but raised in Tokyo. After graduating in Japanese painting from Musashino Art University, she moved to the city of Kochi in the prefecture of the same name, where she worked in a local gallery.

In 1991, she joined a workshop in Kyoto presented by Hisako Sekishima, one of Japan's foremost basket weavers. She then returned to Kochi and started learning to make bamboo baskets. Then she began weaving baskets from mulberry bark. Iwatani left the gallery in 1993 to dedicate herself to weaving objects from plants to fully express herself. She was taken by the beauty of the plants that grew in open fields and along river banks, and felt she could preserve that beauty by weaving them into objects. At the same time, she wove mulberry bark into useful everyday items.

Once Iwatani found herself drawn to magazine photos of woven brooms from Kentucky. That drove her to visit a broom craftsman in Kanuma, Tochigi Prefecture, a town famous for broom-making, to learn the craft. For handles, she now gets town workers to give her branches when they prune the trees lining the streets near her home. And she uses rushes from the river bank for the broom ends.

Iwatani began entering her products in public exhibitions and private exhibitions, slowly earning a well-earned reputation. In 2004, she was invited by fashion designer Jurgen Lehl to exhibit at his outlet in Fukuoka. "Useful items like mulberry baskets and brooms have to be made within the limits of their purposes," she says, "while weaving works of art has no such limitations—I can express myself freely. Still, I try to balance my work, and I have fun at it."

Contact: Zakka
E-mail : zakka-h@mx5.ttcn.ne.jp

Pages 98–99
CALLIGRAPHY BRUSHES

Page 98, from left: L66×W4.5cm (L26×W1⁵⁄₆in.), L24×W24cm (L9⅜×W9⅜in.), L9.5×W3cm (L3⅚×W1⅙in.)
Page 99, from left, top: L22×W2.5–9cm (L8⅔×W1–3½in.), L19×W2–5cm (L7½×W⅘–2in.), L33×W14cm (L13×W5½in.), L35×W12cm (L14⅘×W4¾in.), L33×W5cm (L13×2in.)

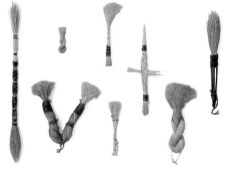

AKEMI AZUMA

Akemi Azuma was born in Tokyo's Nakano ward in 1944, where she also grew up. Azuma is a calligrapher who also teaches calligraphy to children in her home. So she naturally takes great interest in brushes.

The town of Kumano in Hiroshima Prefecture is known for its traditional brush-making, and is where Azuma first saw brushes made of rice straw. Deciding to try making them herself, she convinced a brush craftsman to teach her the fundamentals. Compounding trial and error, she developed a unique style, making brushes unlike any other. For example, she devised brushes for disabled people. These brushes let users push their fingers into the straw handles, fixing the brush to their hand, and allowing them to write.

Azuma gets her straw from several places, including from a farmer in Chikura, Chiba Prefecture. Fortunate chance meetings have given her access to hard-to-find straw from various kinds of rice—*shiromemai*, a type of rice that has been bred back to Edo-period characteristics; red rice, an ancient wet paddy strain; black rice, another old strain; green rice, which came to Japan in the Jomon period; and *kaorimai*, which is known for its fragrance. "I don't know how long I can keep thinking up new shapes, but I'd like to try," she says.

In 2001, Azuma participated in the Japan Year in France, traveling there for the Rice and Wheat Festival.

Contact: Akemi Azumi
FAX: 03-3361-2126

Pages 101-103
DRINKING GLASS SET *"Sake dogu"*

SS W4.6×H8cm (W1⅘×H3⅛in.)
S W5.4×H9.7cm (W2⅛×H3⅘in.)
M W6.5×H11.5cm (W2½×H4½in.)
L W7×H13.5cm (W2¾×H5⅓in.)
LL W7.7×H15cm (W3×H5⅞in.)

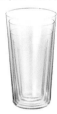

SHOTOKU GLASS

Shotoku Glass Co., Ltd., was founded by Shotaro Muramatsu. Muramatsu was born in Niigata in 1889, but spent his youth in Hokkaido, where he learned his trade at the Fujii Glass foundry in Otaru. He then moved to Tokyo where he established the Shotoku foundry in 1922. Since then, the foundry has been destroyed twice, once by the Great Kanto Earthquake of 1923 and once by the Allied bombings during World War II. Today, it operates in Tokyo's Sumida Ward. The present company president is Kunio Muramatsu.

In pre-war years, the foundry made glass light bulbs, tableware, and glass art works, but after the war, they concentrated on light bulbs and vacuum tubes. In 1958, however, the foundry once again began producing tableware. Today 30 craftspeople work in the foundry, mostly producing tableware.

In 2000, Shotoku began making glasses with lips less than one millimeter thick. These thin glasses were developed when the craftspeople decided to make products they themselves preferred to use.

"In today's world, you can find almost anything you want," says Muramatsu. "But machines can't imitate the skills of master craftspeople. We decided to make glasses so thin that people would be surprised when they put their lips to the glasses."

With techniques learned from making thin light bulbs, blowing thin drinking glasses posed no problems. Master craftsman Hisao Katagiri says, "We were striving for the minimum limit of thickness. Because there's no other ornamental aspect to these glasses, we have to get each one of them exactly right."

Contact: Shotoku Glass
E-mail: gyoum@stglass.co.jp
Related Website: http://www.stglass.co.jp/

ACKNOWLEDGEMENTS

There were many people that have lead me along the path to my first book for an overseas audience, and I am thankful to them all.

First and foremost, I would like to extend my most heartfelt appreciation to the many artists who interrupted their schedules to share their work and their words with me. It goes without saying that this book would not exist without them.

My thanks also go to my editor, Gregory Starr, art director Kazuhiko Miki, Mizuho Kuwata for his marvelous photographs, and tireless translator Charles Whipple. This book is the result of the kind of collaboration for which one always hopes.

While we've tried as much as possible to convey the look and feel of these crafts through words and photos, I know that it is impossible to transmit the smooth coolness of the bamboo, the moist strength of the ironware, the gentle suppleness of the washi. I sincerely hope that readers will have the opportunity to see the actual works and experience their wonderful touch.

Finally, I would like to dedicate this book to my mother, who is presently hospitalized. I feel extremely lucky and blessed to be able to deliver the finished book to her.

(英文版) インスパイアード・シェイプス
INSPIRED SHAPES

2005年7月29日　第1刷発行

著　者　　小山　織
撮　影　　桑田瑞穂
訳　者　　チャールス・ウィプル
発行者　　富田　充
発行所　　講談社インターナショナル株式会社
　　　　　〒112-8652 東京都文京区音羽 1-17-14
　　　　　電話　03-3944-6493（編集部）
　　　　　　　　03-3944-6492（営業部・業務部）
　　　　　ホームページ　www.kodansha-intl.com
印刷所・製本所　　大日本印刷株式会社